Fundamentals of
Watercolor Painting

A revised and enlarged edition of The Technique of Water-Colour Painting

Fundamentals of Watercolor Painting

by Leonard Richmond and J. Littlejohns

WATSON-GUPTILL PUBLICATIONS · NEW YORK
PITMAN PUBLISHING · LONDON

Paperback Edition
First Printing, 1978
Second Printing, 1978
Third Printing, 1979

First published 1970 in the United States by Watson-Guptill Publications,
a division of Billboard Publications, Inc.,
1515 Broadway, New York, N.Y. 10036

Published in Great Britain and by special arrangement with Pitman Publishing Ltd.,
39 Parker Street, Kingsway, London WC2B 5PB,
whose *The Technique of Water-Colour Painting,* © Executors
of the late Leonard Richmond and Miss M. F. MacKinnon, 1965,
furnished the basic text for this volume.
ISBN 0-273-01229-0 Pbk.

Library of Congress Catalog Card Number: 78-98153
ISBN 0-8230-2076-2 Pbk.

Manufactured in U.S.A.

CONTENTS

LIST OF COLOR PLATES

Note about the illustrations: All the diagrams and most of the sketches and pictures have been specially painted for the purposes of this book. Most of the originals were deliberately made very small so that the process could be more clearly shown. In some cases their usefulness as illustrations of particular methods has detracted from their artistic qualities. This fact should be borne in mind when using any of the methods described in this book.

INTRODUCTION

THE OBJECT OF THIS BOOK is clearly defined by its title. It is concerned solely with the problems of technique, i.e. the manipulation of materials. The authors hope that by directing attention exclusively to the craft they may enable the reader, eventually, to pursue the art unimpeded by many of those technical difficulties which often prove to be sources of perpetual embarrassment. The handling of watercolor is so much more exacting in its difficulties and extensive in its possibilities than any other branch of painting, that the authors have been prompted to confine themselves to the consideration of technical problems.

Many excellent works on the art of watercolor painting have been written by distinguished artists; but most, if not all, describe only that method which the writer happened to use—a method which, though perfectly suited to the temperament and purposes of that particular artist, may or may not especially appeal to the reader, and could not conceivably appeal to all readers. Such a book tends always to convey the misleading impression that the particular method described is best for the reader because it was best for the writer, and is necessarily superior to all other methods. The intention of the authors, on the contrary, is to advance no personal opinion as to the relative artistic value of any method, but to deal with all the methods tried by them and leave the reader to adopt, or adapt, whatever makes the strongest appeal.

The field of inquiry is so vast that no pretense is made to make more than an approach to a complete survey. The authors can do little more than suggest a plan of investigation and indicate certain starting points for further research. To the few who are content to follow thoughtlessly in another's footsteps, this plan may be disappointing; but to the many eager students who are seeking the path of personal expression, the authors believe that the wider horizon, with its prospect of adventure and discovery, will provide a healthier stimulus.

L. R.
J. L.

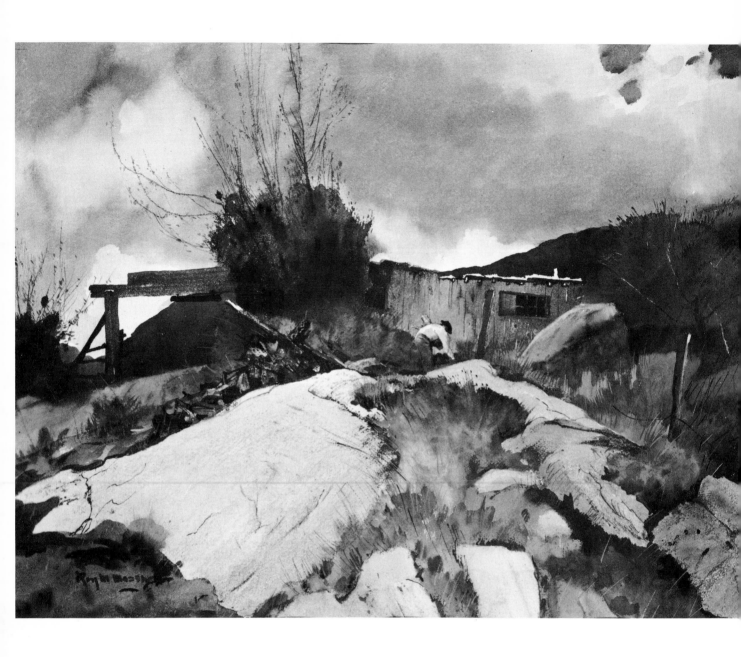

THE BANNER QUEEN TRADING POST
by Roy Mason.

This unorthodox composition is built around the massive pyramidal rock formation in the immediate foreground, which occupies almost half the painting. At the peak of the rock formation is a little figure who forms the vortex around which revolve a burst of vegetation, a brief glimpse of the trading post itself, the tilting form of the landscape beyond, and the surging clouds. The entire painting is full of movement and vividly communicates the feeling of a windy day with an impending storm. Not only the clouds, but the slender branches of the central tree tell us the direction of the wind. (Photograph courtesy American Artist.)

chapter
one

MATERIALS

Nearly all problems, particularly those of a complex nature, can be simplified by clear statement; in fact, the statement often suggests the solution. Let us set down, then, in so many words, first in general and then in detail, the whole problem of technique in watercolor painting.

Given the materials—colors, brushes, paper, mediums, and accessories—how can we represent any combinations of form, tone, and color, limited only by the nature of those materials? That is the general problem. Now let us further define by division, take each material, describe its qualities, and state the individual problems.

Colors

Watercolors can be divided into two kinds: *transparent* and *opaque*. The distinction is imperfect because some pigments, classed as transparent, are less transparent, that is to say more opaque, than others. What are called transparent colors are those composed of pure pigment and a little gum to make them adhere to the surface of the paper. When they are spread over the paper by means of water, the paper shows through, unless the color is applied very strongly; the greater the proportion of water used, the more transparent the color, because a larger surface of paper is visible between and through the particles of pigment.

Transparent colors can be made more or less opaque by adding Chinese white—a method which extends its possibilities in some directions and limits them in others. What are generally called opaque colors are those composed of pigment and gum mixed with a medium which enables them completely to cover the surface, so that the same result can be obtained on a black paper as on a white paper. The thickness and opacity of opaque watercolor, however, can be modified by the addition of water. In the United States, opaque watercolors are normally sold as "designers colors" or "gouache."

The problem, therefore, is to discover what each color and each kind of color can do, singly and in combination, in any given circumstances.

Choosing Colors

In this matter, the artist is in the hands of the manufacturers, and, fortunately, is exceedingly well served. There never were so many reliable and well-ground colors as at the present time. Nor are the differences in quality among the standard well-known makes by any means as great as artists seem generally to believe. There is a tendency for artists to swear by what they are accustomed to using, with little knowledge of the products of other makers. For the beginner, and for others who have not acquired any preferences based on prejudice, the best plan is to try each kind; Certain manufacturers supply a few colors with unique attractions, and that the rest differ but little.

All manufacturers of any standing clearly state in their catalogues the origin of each color and its degree of permanence. One word of warning should be borne in mind. Some of the fugitive (impermanent) colors are so alluring that it is hard to part with them after close acquaintance.

Brushes

Fine pictures can be painted with ill-prepared colors, but inferior brushes would severely handicap a technical genius. If a brush is not really good, it is just bad and merits no consideration. Whatever the circumstances, there can be no economy in this direction. Only the best will do. The market is crowded with rubbish, made of hair which defies the best workmanship. A hundred of such are not worth one good brush.

A brush should be springy without being stiff, come to a point (that is if it is made to come to a point) without hesitation, and last long enough to make it far cheaper than any substitute. For ordinary use, there is nothing to beat the finest red sable; for additional purposes—washing out for instance —brushes with stiffer hair are essential.

The choice of shape is a matter of personal preference, but in the matter of size there is only one safe rule: never use a small brush if it is possible, by practice, to make a larger one do equally well, because there are so many occasions when speed is all-important. As individual brushes of even the most expensive grade vary in quality, each should be tested before buying.

Papers

The nature of the surface to which the color is applied is a highly important factor, deserving more attention than it generally receives. Most artists habitually use a very small number of the recognized makes and, by so limiting the scope of their work, tend to stultify their powers. There are, perhaps, greater opportunities for the extension of watercolor in this department than in any other. For this reason, several illustrations bear directly on this branch of the subject. The characteristics of paper which concern the artist are: thickness, surface, absorbence, tone, color, and permanence.

Thickness: The thinner the paper, the more quickly it stretches and buckles

under the influence of moisture. As it is impossible to paint on a wavy surface, a method of painting has to be devised to obviate these occurrences, or the paper, however attractive in other respects, must be avoided. Paper of medium thickness can be made amenable to certain methods if stretched on a drawing board or on a wooden stretcher frame or pasted onto cardboard; but if more than a certain amount of water is absorbed, it stretches again and becomes useless. Here, then, is one of the minor problems of watercolor painting: how to successfully apply color to papers of any given thickness. There are so many thin papers with such delightful qualities of surface and delicacies of tone as to justify the adoption of special methods and the selection of special subjects rather than pass the papers by.

Surface: Almost any surface, from the smoothest to the coarsest, can be used with good effect, and each kind can be induced to display its special charm by the adoption of suitable subjects and methods. For instance, a smooth white paper will give the impression of white in the untouched parts when framed and hung on a wall, while a coarse paper, in the same circumstances, will look gray and mottled. A wash of the same color, therefore, would appear darker on the coarse paper, as if thousands of dots of color, slightly darker than the wash, had been added. One does not need to be highly imaginative to know that a cloudless sky, which on a smooth paper would look opaque and dull, might, on a coarse paper, become radiant and atmospheric.

This is one of the many starting points indicating directions for investigation. Here the problem is to find how the surface can play the part for which it is specifically fitted.

Tone: There are certain reliable papers which are procurable in a large variety of tones suitable for opaque watercolor. Except for the paler shades, however, toned papers are seldom suited to painting in transparent colors alone. But when the palette is enhanced by Chinese white, subjects and effects which the most expert technician would otherwise hesitate to attempt suddenly become simplified. A new field of possibilities is thus revealed. Brilliant contrasts and subtle distinctions can be rendered in a few washes as new powers are realized.

To discover exactly what those powers are will necessitate a number of careful experiments which fall easily into two groups: (1) to know what will happen when any given transparent color is applied to a paper of any given tone; (2) to know what will happen when Chinese white is added to the transparent color. The first group is by far the more important.

Perhaps the whole position can best be explained by a general statement. When any transparent color is applied to white paper the paper is darkened, and the stronger the wash the darker the paper becomes. But when the same colors (except black) are applied to a black paper, the paper is lightened, and the stronger the wash the lighter the color. This statement, true as far as it goes, does not cover the whole ground, because all the colors do not possess the same degree of transparency; indeed, a few of them are decidedly opaque.

The field of inquiry is so great that there is a danger of frittering away useful time in experiments that will never be applied to a painting. The student would be well advised, therefore, to select a number of papers, say, half a dozen, of distinctly varied tones and, by gradated washes of each color on each paper, get a general idea of what these new conditions mean.

The subject need not be pursued here, as it will be dealt with in detail later.

Choosing Papers

A complete list of satisfactory papers is, of course, out of the question, as new varieties, made for purposes other than painting, are often discoverable. But a few remarks about a few standard and other makes will be of service to the beginner. Among the better known brands of papers are: d'Arches (French), Fabriano (Italian), and a variety of English papers which include Whatman (now difficult to get), Arnold, R.W.S., Crisbrook, Millbourn, J. Green, De Wint, and David Cox. All of these papers are handmade—all good watercolor papers are. Watercolor papers come in three surfaces: rough, cold pressed, and smooth (hot pressed). The rough is best for a very bold technique, since intricate brushwork becomes difficult on the irregular surface. The cold pressed is most useful for general purposes. The smooth (hot pressed) takes great skill and is rarely used except by experienced professionals. Each make of watercolor paper has its special characteristics, but, as preferences for any seem to depend on personal taste, the only safe plan is to try all.

Less expensive machine-made paper is little used for serious painting because the cheaper kinds are liable to darken; but stout drawing paper of the finest quality is more satisfactory, in some respects, than the thinner handmade papers. A variety made with a surface like canvas has especial claims, fully explained in connection with Plates XXI, XXXVI, XXXVII, and XXXVIII. A thick handmade paper with this surface would be exceedingly valuable. Indeed, there is room for much extension in this direction. The interesting grains to be found on many modern wallpapers, for instance, if applied to satisfactory material, would supply a considerable and growing need.

Perhaps the most widely favored of all tinted papers are the English David Cox and the French Canson Mi-Teintes. Used by the expert, and with full knowledge of their special qualities, they display unique charms; but they will not stand rough or labored treatment.

Mediums

For the ultra-purist, who scorns all adventitious aids, there is only one medium—water. On this as on all other controversial questions, the writers express no opinions. Mediums *are* sometimes used, and demand consideration.

Mediums are used for two purposes: to insure the maximum brilliance of the color and to give greater control. For the former purpose, some manufacturers supply a quite reliable medium which prevents dark, rich colors from sinking into the paper and becoming dull. But if too much is used, it produces an unpleasant shine. The latter purpose, that of added control, is effected by (1) preventing quick drying, (2) thickening the water so that it moves more slowly, and (3) keeping the color on the surface of the paper. The first obviates many of the difficulties due to heat, the second enables more to be done in one painting, and the third permits wiping out to become a dominant feature. Several prepared mediums are sold by most art supply stores, but glycerin and paste (as will be explained later) serve all the three purposes.

The increase of power which these mediums give will greatly surprise everyone hitherto unacquainted with their use, and will solve the mysterious technical qualities of a good many pictures.

Water

Those who object to the use of any medium, and are not therefore concerned with its handling, are nevertheless confronted with the problem of the manipulation of water. There are several ways of laying on a flat or gradated wash. Damping the paper before painting; soaking it for some time in accordance with the nature of the paper; laying it on a sheet of glass; holding it at certain angles while the color runs in the required direction, are among the prevalent plans. The use of water teems with problems.

Attitude

Granted that the reader genuinely desires to master the craft one question arises immediately: how to set about it? The answer depends largely upon temperamental attitude. The ideal temperament is that which regards the task as a splendid adventure, to be pursued to the utmost limits with a joyful determination, and finds a continual fascination in "seeing what will happen." To the ardently inquiring mind, eager to travel beyond the recognized boundaries, the knowledge of unlimited possibilities will provide a continual inspiration. The danger (to change the metaphor) is to attempt to come to grips with the enemy by disorderly, spasmodic rushes before consolidating each successive position.

Plan

To those who are prepared to follow an extensive as well as intensive course of study the following (admittedly heroic) plan is recommended:

(1) Work out all the preliminary exercises.

(2) Add any others that occur.

(3) Copy the illustrations exactly in accordance with the descriptions.

(4) Apply the methods to other subjects.

(5) Combine two or more methods on still further subjects.

(6) Extend in any direction suggested by previous efforts.

A few words of warning cannot be too often repeated and emphasized: the practice of watercolor is peculiar in that some apparently little thing may, in a minute, cause irretrievable ruin. A dirty brush, an insufficient quantity of color prepared for a wash, the absence of some accessory may spoil an expensive piece of paper covered with a painting representing a day's work, and may generate a disastrous state of exasperation.

Do everything to avoid the possibility of any preventable accidents, so that the work can be pursued in an atmosphere of cheerful calm. Work at or near a table large enough to contain everything that may be required quickly, and get into the habit of placing each article always in the same place so that it can be found at any moment. Never forget that the three most malignant enemies are hurry, uncertainty, and irritation.

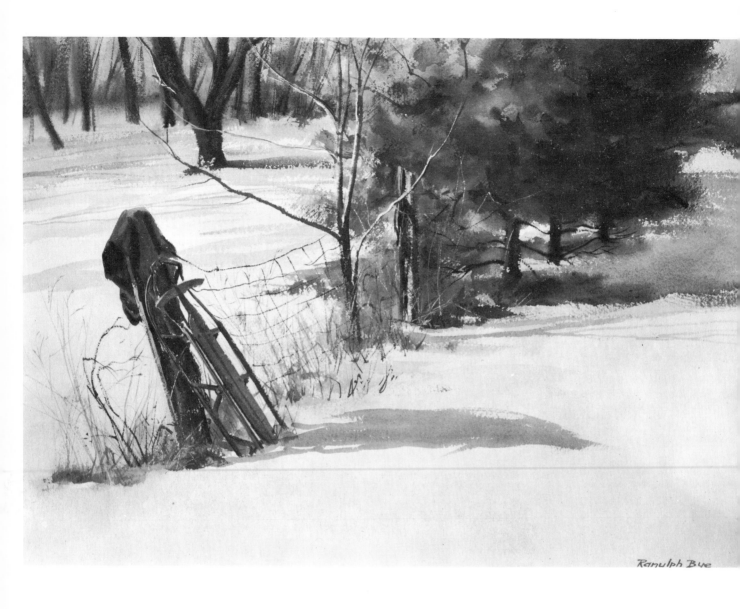

THE BACK SLOPE by Ranulph Bye.

The beginning landscape painter must learn that snow is not uniformly white and is not a shapeless blank, but does actually have form and contains a variety of tones within its whiteness. Study how this artist has painted the delicacy of the snow in a variety of extremely pale tones, allowing the whiteness of the paper to shine through, but giving the snow a distinctly three dimensional quality. His handling of the snow in the upper left is particularly interesting, where tree shadows fall across the snow and suggest the rolling shape of the landscape, which is not absolutely flat, but has a faint roundness to it. This roundness is most firmly stated in the shadow of the sled and fence post in the foreground—the shadow has a distinct curve which suggests that the drifting snow curves as well. The blurry clump of trees in the upper right is an excellent example of wet-in-wet painting, with the distinct darks of the trunks blurring into the foliage. It is also worthwhile to study how washes —like the shadows of the trees in the upper right— allow flecks of white paper to shine through and also have drybrush edges. (Photograph courtesy American Artist.)

chapter

two

LAYING
A WASH

Only the experienced, with unhappy memories of a long succession of blunders behind them, can fully appreciate the value of learning to lay a wash with ease, speed, and certainty. Any reader, therefore, who has the slightest doubt of his powers in that direction is earnestly advised to postpone all other considerations till the necessary skill is acquired. A few hours concentrated on this single object will not only save months of misguided effort, but will lay the foundation of technical efficiency. Laying a wash is the fundamental operation in watercolor painting.

How to Lay a Flat Wash

There is no special difficulty in laying a wash. It is not a gift. Little more than care, common-sense, and practice is required. If the following directions are followed, success should be only a matter of a little time.

(1) Mix the required color in a saucer. Mix more than, to the inexperienced, appears to be required.

(2) Choose a suitable paper, thick enough to take a wash without perceptible swelling, for if the surface does not remain quite straight the wash is bound to be uneven. A thick paper stretched on a drawing board, or pasted to thick cardboard and thumbtacked to a drawing board, provides a satisfactory surface. Place the board so that it inclines at an angle of about 30°.

(3) Dip a small sponge into perfectly clean water and squeeze out about one-half of it. Pass the sponge lightly over the whole surface.

(4) Now take a large, wide, flat, fat brush; charge it fully; and with a long, light, steady, deliberate stroke, draw it right across the top of the paper. Part of the color will run down, forming a long pool at the bottom of the stroke,

while the brush is again being charged. Let the second stroke overlap the first by about half an inch. Continue the process till the surface is covered.

Make the first attempts with much diluted color, because the stronger the color, the more difficult it is to handle. Note, for future use, which colors are most amendable. Preserve the successful results; perhaps later they can be used for pictures.

Gradated Wash

Next, try a gradated wash. Mix a quantity of fairly strong cobalt blue. Make the first stroke as before. Then, very quickly, take a brushful of water which dilutes the color in the brush and add it to the mixture for the second stroke. Proceed in this way right down the paper, diluting the paint with more water for each stroke.

A smaller amount of color is necessary for a gradated wash. The greater the gradation required, the less color should be mixed. Only practice can determine the exact amount. As with the flat washes, let the practice of gradated washes serve a practical purpose. Choose colors and combinations that can be used later for cloudless skies. The following exercises will suggest a fruitful line of procedure.

(1) *For a midday sky*: Lay a wash of very pale vermilion gradating to nothing. Turn the paper upside down and lay a gradated wash of cobalt blue, of medium strength to pale, over the vermilion wash. See that the first wash is thoroughly dry before applying the second.

(2) *For an afterglow*: Lay a wash of yellowish orange gradating from rather strong to rather pale. Turn the paper upside down and a lay a wash of cerulean blue gradating from rather pale to very pale.

When very large spaces have to be covered, the brush can be replaced by a small sponge. A sponge is not easy to manipulate on a hard surface, as it tends to suck up the color; and great care must be taken to handle it very lightly for fear of injuring the surface of the more delicate papers.

This method, particularly when applied to large surfaces, is open to several objections: there is often a danger that the second wash may disturb the first; in the most skillful hands, the possible number of superimposed washes would therefore be severely limited; if the more opaque colors were used, a distinct loss of transparency might ensue; and the slightest error in manipulation or strength of wash would mean complete failure. A modification of this method, washing down, will solve all these difficulties, however.

Washing Down

Lay each wash appreciably stronger than finally required, and when it is absolutely dry, wash it down with a large, flat, rather stiff brush, and pure water. By this means, the wash will not only be lightened to the extent required; slight unevennesses can often be removed; greater transparency is certain; succeeding washes can be laid with little or no fear of disturbing the previous ones; and any number of washes can be superimposed.

A few experiments will give some idea of what extraordinary subtlety, combined with considerable force and transparency, can be produced by a succession of contrasting tints. The following exercises, when compared with the first of those suggested above, will serve to indicate the possibilities and value of the modification.

(1) *For a midday sky*: Lay a pale wash of yellow ochre gradating to nothing. Wash it down. Superimpose a pale wash of rose madder gradating to nothing. Wash it down. Turn the paper upside down and superimpose a rather stronger wash of cobalt blue gradating to paleness. Do *not* wash it down. (This example is illustrated in Plates I and II with a simple form of landscape, painted in stronger washes of the same colors used for the sky.)

(2) *For an afterglow:* Lay a wash of cadmium yellow, gradating from fairly strong to rather pale color. Wash it down slightly. Lay a wash of vermilion gradating from rather pale to very pale color. Wash it down slightly. Turn the paper upside down, and lay a wash of cobalt blue gradating from rather pale to very pale color. Do *not* wash it down. (This example is illustrated in Plates III and IV with a simple form of landscape painted in stronger washes of the same colors used for the sky.)

Exercises of this kind, when successful, need not be treated as mere experiments. They should be used as skies for actual pictures as was done on Plates I and II, III and IV. The knowledge that each successful attempt is a picture partly painted should stimulate the student to try many unusual combinations. It will be found that the same colors, used more strongly and in different proportions in the remainder of the picture, will almost certainly produce an effective harmony.

Those who have not tried will be surprised to find how many varieties of cloudless skies can be obtained by the use of three colors painted in the manner just described. The following, among others, might well be tried: successive washes of aureolin, viridian, and cobalt violet; black, burnt sienna, and ultramarine blue; light red, emerald green, and cobalt blue.

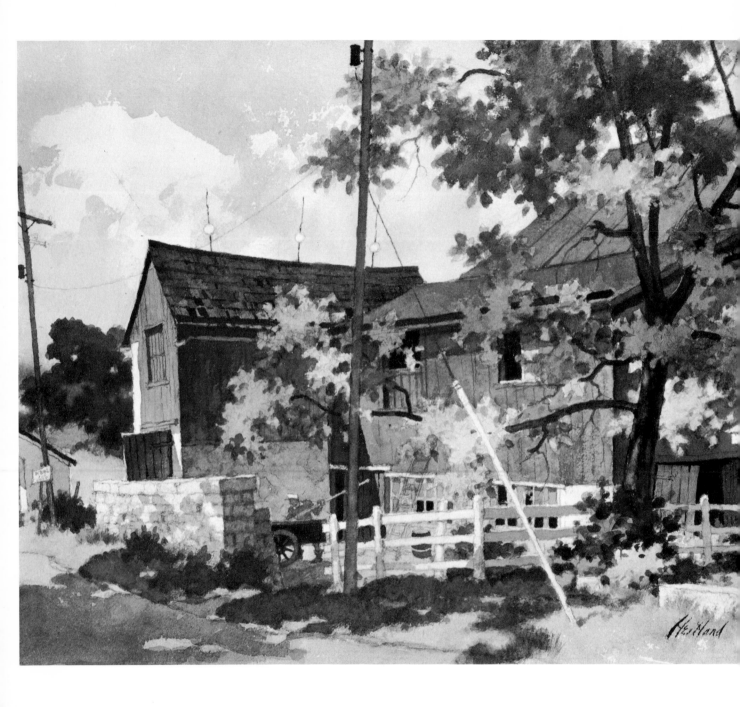

HOBSON'S BARN by W. Emerton Heitland.

When working in transparent watercolor, nothing is more difficult than painting intricate light shapes against a dark background. These shapes must be designed and visualized far in advance so that the artist can paint the darks around them first. Here, the lively effect of the foliage is the result of planning the clusters of leaves first, leaving the paper bare, and painting the shadowy buildings around the clusters, which are then washed in with the appropriate colors. It is particularly interesting to note that not all the clusters of leaves are the same tone; some are light and some are darker, but the artist has worked around them all with extraordinary skill. The traces of pencil line that remain in the foliage masses suggest that these shapes were drawn carefully in advance so that nothing would be left to chance when the darks were painted around them. The pencil lines have been left in and add to the lively texture of the foliage. (Photograph courtesy American Artist.)

chapter
three

COMBINING
COLORS

THE DIAGRAMS in Plates v and vi are intended to indicate a method for discovering what can be done with the pigments at the disposal of the water-color painter. We chose three of the brightest and most vividly contrasted colors: alizarin crimson, ultramarine blue, aureolin. The object is to find (1) what happens when any two colors are superimposed, and (2) what happens when two or three are mixed.

Three facts will immediately occur even to the most unobservant—the enormous range, brilliance, and variety made possible by such a simple means. It would almost appear as if no other pigment need be used to produce any combination of tint and tone. Further experiments with other pigments, however, will reveal the limitations. For instance, Antwerp blue and chrome yellow will produce a more livid green. But if these plates do nothing more than promote a desire to wisely restrict the palette for any given picture, an excellent purpose is served.

Know your Materials

Most students, and not a few painters, use a large number of pigments when half the number would cover the same range. This is not a suggestion to select a few colors and stick to them for all purposes; it is a plea for getting any given range by the simplest possible means. The painter's business, as a craftsman, is to know the utmost his materials are capable of doing, and to develop the skill to exploit their characteristic qualities. The expression of a conception is difficult enough in the most favorable circumstances. No artist can afford the expenditure of time, and the wastage of nervous energy due to any lack of knowledge of the latent powers of his materials.

Pigments

The second impression is just as surprising, viz. the difference between the superimposition of any two colors and the results obtained by reversing this superimposition. Blue on yellow gives a rather dark dull green; yellow on blue gives a light, bright yellow-green. Here the contrast is very marked. The two combinations of blue and red also give differences, but not to the same extent. The explanation of these differences is concerned mainly with the composition of the pigment. What are usually called transparent colors are to some extent opaque—the term transparent is only relative—and the more nearly opaque the pigment, the more it influences the combination—another fact revealing a new field of inquiry. The recognition of these fundamental facts will give purpose and direction to the consequent investigations, which should continue in a perfectly orderly way, proceeding from the powerful and obvious to the subtle and refined.

Primary colors: First, try all the combinations of red, blue, and yellow—from Antwerp blue, chrome yellow, and vermilion to cobalt blue, light red, and yellow ochre—and note the progression from the strident and postive to the delicate and elusive. Then take sets of three pigments, excluding red, yellow, and blue, and in proceeding down the scale, note when colors are repeated, and, what is much more important, observe how restricted combinations often produce satisfying schemes for particular purposes. Whenever one occurs, use it in a picture, or in a sketch for a picture.

Secondary colors: Plates VII and VIII show experiments with cadmium orange, emerald green, and cobalt violet, in the same manner as was done in Plates V and VI with red, yellow, and blue. It will be noted, first of all, that while the combination of pairs of red and yellow, yellow and blue, blue and red, yield approximations to orange, green, and violet respectively, a mixture of the three gives variations of gray. But similar combinations of orange, green, and violet produce more neutral and less obvious results. There is a decided preponderance of cold colors. In one respect, there is a similarity: a mixture of all three colors, at full strength, and in the requisite proportions, produces a color that is almost black, which, diluted with water, will give almost any tone of practically pure gray.

This striking fact suggests experiments in combinations of colors with actual black pigment which will be found to give remarkable results, adding considerably to the range of subtle neutral colors and simplifying many problems of color harmony

Modified colors: Plate IX shows a few examples which can be extended in many directions. A shows red lightened to varied tints by adding water, and darkened to increasingly dark shades by adding more and more black. The same experiment with red-orange gives a much more extended range, as is shown in B. Here, the shades have a decidedly brown tinge. With orange the shades become rich browns (C), with yellow-orange, russets (D), and with yellow there is a suggestion of warm green (E). With green (F) and blue (G) the changes in color are not so great. H illustrates an additional range which can be obtained only by the use of opaque colors. The pure color is modified, not by adding water or black, but by using varied tones of gray.

The richness of this collection cannot be reproduced perfectly, but the reader should carry out each experiment in order to gain an insight into the tremendous possibilities of these and other combinations made on similar lines. One important result would follow immediately, viz., a removal of the popular but illogical objection to the use of black.

The most instructive method of investigation is to take the brightest colors first and discover the possibilities of each separately as is done on Plate IX, then to take several dyads (pairs of colors), next several triads (three colors), and finally tetrads (four colors). It is impossible to overestimate the importance of such inquiries, especially when each is immediately applied to some pictorial purpose.

Plate X illustrates one of the most effective arrangements, viz., a sequence of warm colors (red, red-orange, orange, and yellow-orange) opposed by the most contrasting color (blue), and each color modified by white, black, and gray. This picture was painted in opaque colors so that each color, in pure or in neutralized form, is kept separate from the others (as could not be done with transparent colors), and in order to show the subtle effects of the use of gray. Each color maintains its distinctive character, giving greater decision to the general effect. This is an aspect of watercolor which has not yet been sufficiently explored. Exercises upon such lines would have a healthy influence on anyone whose color mixtures tended to be diffuse and uncertain—an all too common characteristic in the work of most beginners, and not always absent from the pictures of many others!

It need not be said that to attempt anything approaching exhaustive experiments into every conceivable combination would be absurd, because no time would be left for painting. But there can be little doubt that in the early stages of a painter's career an hour spent in intelligent and methodical analysis will save a day of misadventures and accompanying disappointment.

What Makes a Good Painting?

If any evidence is required to provide stimulus to the student, a visit to almost any exhibition of miscellaneous watercolors will emphasize the need for knowledge. Here and there pictures stand out by reason of their clean efficiency, and appear to be painted with superior colors, while some of the other pictures seem to be made of mud.

Though it is true, of course, that the most efficient technical display may be an entire failure as a work of art, it is just as true that bungling and ignorance always tend to a decrease in artistic value. The ideal picture would be a combination of supreme conception and perfect technique.

The plan of approach to watercolor painting laid down in this chapter may surprise those who have been taught to commence by attempting to imitate nature as accurately as possible before considering questions relating to technique and composition. The authors are convinced that this time-honoured way is responsible for much unnecessary blundering and failure. Most students who start out with a well-filled box of pigments, and with no system of investigation, go on mixing this, that, and the other color, and make a series of messes which leaves them well-nigh hopeless. And when, after muddling through, they eventually manage to achieve a fair imitation of some effects of

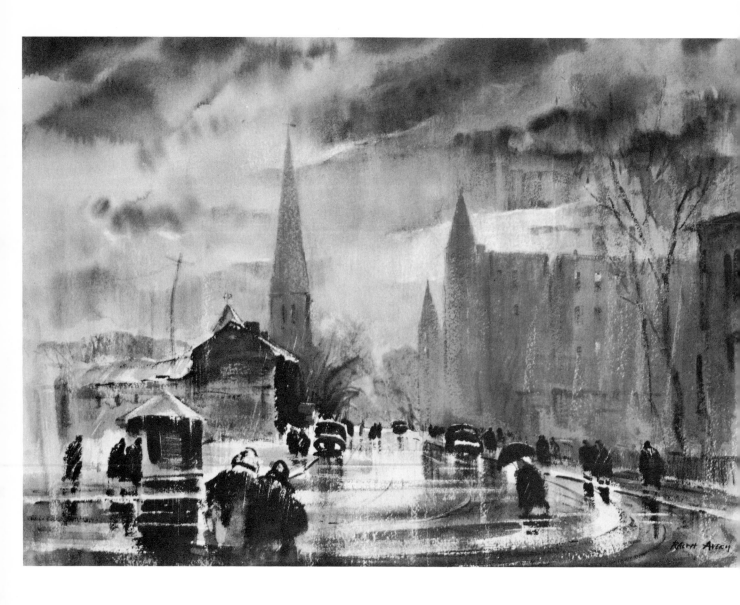

SPRINGTIME REFLECTIONS by Ralph Avery.

Rain is a fascinating and difficult subject to paint in watercolor. This artist has solved the problem very effectively by a combination of wet-in-wet effects and drybrush strokes, which often melt together. The sky is obviously painted on wet paper, but the soft strokes have been pulled downward to give a sense of falling rain. These vertical strokes appear throughout the entire townscape of buildings, street, and figures, which are frequently rendered in vertical strokes, and which appear to be modified by vertical knife or razor blade strokes *that scrape away vertical reflections and touches of light. Notice how the dark shapes of the figures and the cars are carried into the wet shapes of the street, and are echoed in the reflections. The whiteness of the paper constantly breaks through the drybrush effect in the foreground, creating a fascinating flicker of light that animates the entire painting. This light breaks through and around the darks and the halftones, which are never flat, but always charged with vitality. (Photograph courtesy* American Artist.)

nature, they find that they are little, if any, nearer to the production of a beautiful picture. They then realize that the genuine artist can paint, with very few pigments, a far more satisfying composition than they are able to do with the whole assortment provided by art supply stores.

While it is true, of course, that the creation of a work of art demands a profound knowledge of nature, it does not follow that the early essays in painting pictures should consist of attempts to copy every intricacy of natural effects. Most painters who have approached the problem unsystematically have begun by crowding and ended by simplifying their palettes. We suggest that the student begin by learning to control the simplest combinations and proceed, step-by-step, to the more complicated ones, perfecting his technique as he goes. He will then be more likely to discover that the expression of beauty is not only a matter of imitating superficial facts of nature, but of interpreting its deeper qualities. He will not be led away, by concentrating attention upon insignificant details, from the fundamental principles of nature—unity, simplicity, vitality, and repose. He will learn to look at nature in a big way.

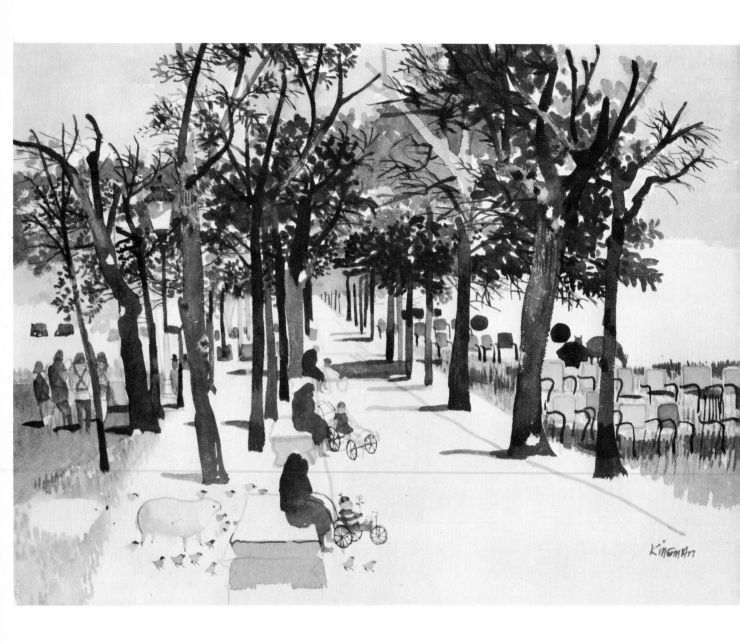

TREE ROWS IN MADRID by Dong Kingman.

For the painter who works in transparent water-color, the strongest light in his picture is always the white of the paper itself. Here the foreground has been barely touched with paint, allowing the white of the paper to shine through and create the effect of the strong Spanish sunlight. Against this flat, intense light, the trees and figures are rendered as flat shapes in silhouette. The artist's entire approach is unusual. All the main shapes of the picture are painted flatly, and these forms are then overlaid with small, short, precise strokes which *build up the limited amount of detail necessary to complete the composition. Thus, the women sitting on the benches are literally a single flat, dark shape, over which the baby carriage and the child have been painted with a few linear strokes. The trees begin as flat shapes for the trunks and foliage masses, over which are laid a variety of short strokes for the leaves. The grass is first painted as a flat shape, followed by a series of short, vertical strokes which create their texture. (Photograph courtesy American Artist.)*

chapter four

OUTLINE AND WASH

THE TINTED DRAWING *The Market Place, Siena, Italy* (Plate XI), demonstrates the value of a pencil outline for suggesting more or less detailed information, relating to a subject in which buildings predominate. The yellowish-tinted paper chosen for this drawing creates an excellent impression of warm, luminous sunlight, and is quite suitable for the purpose. In the initial stage, the drawing must be precisely stated, so that it becomes a comparatively easy matter to lay on the varying delicate color tints in their correct positions.

Tinted Paper

The problem of sunlight is practically solved before a sunny subject is attempted on warm, yellow-colored paper, provided, of course, enough discretion is used not to over-stain the paper with strong colors. Notice how very little color is used in the tall buildings behind the market scene. The delicacy of the color washes should be obvious to the trained eye, when it is realized that the sky is the actual color of the paper. The contrasting depth of tone in the darker tinted foreground accentuates the feeling of warm sunlight as seen elsewhere. The subject is not one that represents an infinite amount of scholarly architectural detail. It is a compositional suggestion of light and shadow; the figures, etc., are merely incidental to the general design.

Students should always remember that, when they adopt this style of painting, the more water they mix with their colors (within reason) the more luminous the result will be.

Pencil Effects

A 5b lead pencil and good drawing paper are the chief items used in the subject entitled *Landscape near Le Puy, France* (Plate XII). If the pencil is really

good in quality, several degrees of intensity, or tone, can be made by passing heavily for the darker tones, and exerting less strength for the lighter tones or lines. Notice how the drawing of the taller trees in the foreground demonstrates the possibilities of achieving deep tone with the aid of a soft black lead pencil.

Since the landscape represents a gray effect (compared with the previous plate) white paper was chosen, as it is more suitable than warm yellow for the purpose.

This picture, like Plate xv, is partly unfinished on the left side, so that the student is able to see the actual drawing, free from any color washes, and also the effect of color tints painted over the pencil drawing.

As the pencil outline is more important than the painting, care must be taken to subordinate the color to the drawing. Although the color is so delicately applied, yet there is no reason why tones should not be correctly suggested. For instance, the whole of the sky is tinted with a slightly colored wash. The mountainous distance, although decided in tone, is exactly the correct depth of tone when compared with the sky. The tall trees in the foreground are neither too light nor too dark in tone: dark enough to assert their position in the foreground, yet light enough to take their place as part of a harmonious whole.

The chief colors used are yellow ochre, purple, and Hooker's green, each being well diluted with large quantities of clean water, with the exception of the dark trees.

Outlining with Ink

Plates XIII and XIV are two stages of a picture entitled *Toledo*, giving an example of the same style as that illustrated in the two previous plates. In this case, the technique is applied to an elaborately detailed composition which is outlined with brown indelible ink.

For the first stage (Plate XIII), use a rather smooth paper, a thick drawing paper or a handmade paper. (1) Make a very careful drawing of every detail with a faint pencil line, or transfer it from a drawing made on a sheet of thin paper. (2) Go over every line with brown indelible ink, diluting with water for the distant parts of the picture. When the ink is dry, clean the whole surface with a very soft eraser or breadcrumbs. (3) Sponge the whole surface with clean water and take off the surface moisture with blotting paper. Then give it a preliminary wash of very pale yellow ochre with a touch of brown. If the picture is not large—say about twice as wide as the example—the painting should cause little difficulty to anyone who has practiced laying flat washes as directed in a previous chapter; because the area of each wash is small, the outlines have a softening effect on the washes, and a little unevenness will often make for improvement.

Commence with the lightest and brightest colors and see that each is quite dry before superimposing. Use the smallest possible number of colors. Yellow ochre, vermilion, ultramarine blue, and viridian, if mixed correctly, will do everything required.

The second stage (Plate XIV), apart from a few corrections, completes the picture by varied washes of gray for the parts in shadow—paler and bluer as

the objects reported recede. Ultramarine blue, vermilion, and a little yellow ochre will produce every shadow.

Regarded as a technical exercise, this is merely an easy introduction to sterner work in future attempts. But regarded pictorially, it is a complete and expressive method, especially when applied to a subject where topographical detail is predominant.

Ink in two colors: Plate xv represents a further development in the use of indelible or waterproof ink, with two colors instead of one. All the foreground objects, such as the vertical trees, shrubs, etc., were strongly outlined, in addition to some massing of forms, in India ink. As the reproduction shows, this ink is brilliantly black. It is therefore important to make the original pencil drawing as accurate as possible, otherwise the dazzling strength of India ink will only help to accentuate bad draftsmanship.

All the subject matter behind the dark foreground was drawn with Vandyke brown waterproof ink. This ink, being light in tone, was used so that the more distant objects in the landscape could have a chance of expressing their correct tones. The depth of black against the Vandyke brown ink helps to differentiate the division between the foreground and the distant scenery. Apart from the charm of color, the contrast afforded by the two inks gives considerable artistic interest to the picture.

It is scarcely necessary to mention that no opaque watercolor should be involved for this method of painting. Any transparent color that is added is only at the best a slight aid as the two inks convey most of the information required. Like Plate xii, the left side of the picture is partly unfinished, so that the student is able to see the treatment of the two colored inks irrespective of the final color washes.

Ink in five colors: Plate xvi shows a study called *The Dolomites*, in liquid waterproof inks. The five colored inks as seen in this picture are each indicated at the foot of the reproduction. They are black, Vandyke brown, violet, cobalt blue, and grass green. The painting was made on a fairly thick white mat board. The system adopted is as follows:

(1) Pencil drawing of the whole subject on ordinary drawing paper.

(2) Transparent tracing paper placed over the original pencil drawing, and an outline made of the subject with a small sable brush dipped in India ink.

(3) Soft charcoal is rubbed on the back of the tracing paper, then the tracing paper is placed on top of the white matboard with the India ink drawing on the outside. The drawing is easily transferred to the matboard by pressing lightly over the ink outlines with an HB pencil.

(4) The charcoal lines can then be drawn in colored inks. After drying, the matboard should be cleaned by flicking with a clean dustcloth, or by using a kneaded rubber eraser.

The whole of the picture was outlined with the different colored inks, then afterwards the flat shadows were filled in, so as to give solidity to the various portions of the landscape. (The unfinished section on the right side demonstrates the correct way in which to commence the picture.)

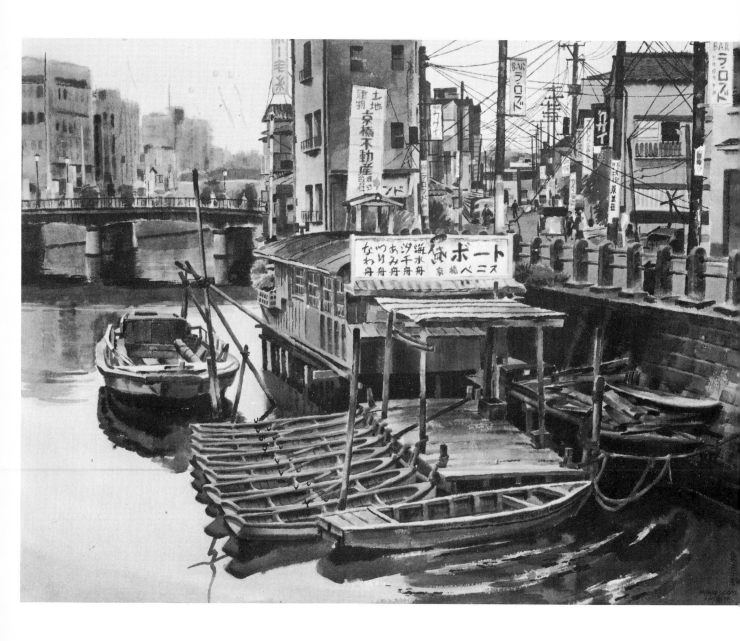

CANAL IN TOKYO by Mario Cooper.

The artist has used two valuable devices for organizing the potential chaos of this complex cityscape. The perspective lines of the roadway, the buildings, and the boats all channel the viewer's eye through the maze of detail. And the artist has exploited the contrast between the confusion of the townscape and the area of calm created by the water and the reflections. It is also worthwhile to *study the ways in which he has rendered the various textures of the materials in the painting: the wooden boats and nearby buildings; the stonework to the right; the calm water; and the crisp paper signs. The artist switches deftly from flat washes to graded washes to wet-in-wet to drybrush, depending upon the problem at hand. (Photograph courtesy American Artist.)*

Ink and Water

Several gradated tones can be made with indelible inks by adding water. Notice in the reproduction three different tints of grass green. Also two decided tones of blue, one in the nearer range of mountains and the other in the farther range. Black and brown harmonize excellently together, as seen in the black firs on the left, showing patches of brown material, thus avoiding monotony of color. The bluish purple shadow on the extreme left side, cast by various trees, is a mixture of blue and violet from the original colors at the foot of the reproduction; but very little mixing, or dilution of colored ink, should take place, as it is not advisable to imitate the usual methods of genuine watercolor painting.

Importance of Good Draftsmanship

Outline and wash is an excellent test of artistic ability. There is no hiding good or bad draftsmanship, whereas in opaque watercolor painting good color effects can often blind the eye to the lack of sound constructive drawing. Curiously enough, the more detail shown in a drawing on watercolor paper, the less color is needed to complete the picture. On the other hand, when the preliminary drawing is slight or lacking in detail, more color will be required to convey the artist's intentions

Clarity

The chief asset to outline and wash is the luminosity of the color washes. Even colors labeled "opaque" present all the charm of transparency when diluted generously with water.

To retain the clearness of the original drawing in Plates XI and XII it was necessary to use larger quantities of clean water so that the color washes would only "stain" the drawing paper.

Instances have been known in which the original drawing was partially lost through the color washes being too dark in tone, and attempts made to restore the subject by redrawing with the lead pencil over the colored ground. This practice destroys the charm of outline and wash, since there is a certain greasy quality in lead which causes the surface lines to shine, or reflect light, in a most unpleasant way.

The chief reason for using indelible inks is to get clear and definite forms in drawing and color (whether they look artistic or inartistic) so that the painter has something of practical value for reference in the studio.

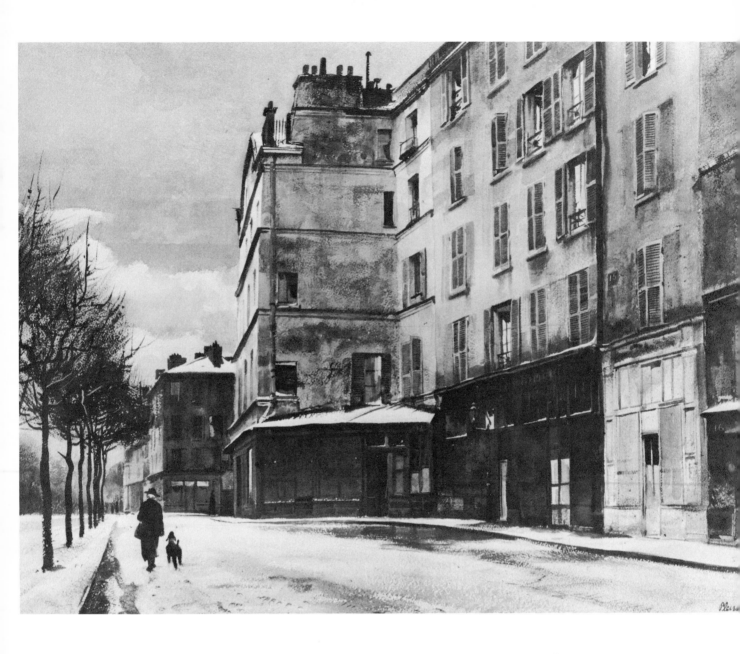

SUNDAY MORNING by Ogden M. Pleissner.

A very low vantage point—which means a low horizon—has been chosen to emphasize the loftiness of the buildings. This also creates a strong sense of receding perspective, with the buildings and the row of trees channeling suddenly downward to the focal point of the picture, where the woman and her dog step toward the vanishing point of the perspective lines. The buildings are developed by combining flat and graded washes of color with overlying drybrush strokes and textures. The street in the foreground is animated by big drybrush strokes which lead the eye back to the center of interest. Notice how simply the trees on the left are painted: each trunk is a single, strong, decisive stroke of dark, leading upward into a mass of drybrush texture and more crisp strokes of the branches. Notice also how the sky and the generally gray quality of the light communicate a real and marvelous sense of atmosphere and weather. (Photograph courtesy American Artist.)

chapter
five

WASH
AND
OUTLINE

PLATE XVII ILLUSTRATES THE FACT that the distinction between "outline and wash" and "wash and outline" is a very real one. The first tends to create rigidity as it encourages the painting of small patches to fill the spaces between outlines. Otherwise many lines might become partly or wholly obliterated by dark, or partially opaque, colors. The second, by postponing the ink outline to the final stage, suggests the painting of broad masses and full tones without restraint.

Breadth and Detail

Used to the full extent, this method is, admittedly, not a method for a beginner. A fairly accurate copy of Plate XVII is a comparatively easy exercise, but the application of the method to original composition is by no means simple. It needs power born of cultivated taste and ripe experience. The possessor of the faculty for seizing sudden inspirations with deftness and force will find this method an admirable one for combining a general effect of breadth with the delineation of intricate detail. The subject was chosen to show how the representation of great masses of sunlight and shadow can be strengthened rather than modified by the emphasis of detailed form in nearly every part of the picture.

In making a copy of Plate XVII, use a thick paper with a smooth surface. Make a clear drawing in pencil. Indicate the main divisions and the exact shape of the distant hill very clearly, but show only the boundaries of the woods. Except for the sky, allow the colors to run slightly into one another. Endeavor to keep the whole picture wet. Take off color with a clean brush and add darks as the paper dries. If, accidentally, an interesting shape should occur, try to make use of it. But be most careful to retain the tonal relations— the light distance and foreground and the dark middle distance.

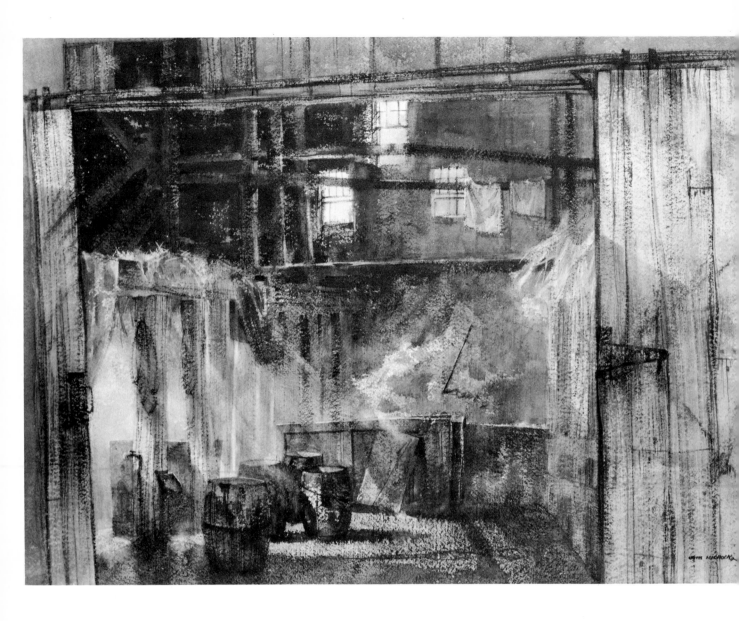

INTERIOR SUNLIGHT by Tom Nicholas.

It is important for the beginning landscape painter not to restrict himself in his definition of what is a "landscape." This painter has seen a landscape subject in a glimpse through an old warehouse, past a variety of beams and other architectural elements, to the lighted windows of a building beyond. The subject is framed by the boards of the warehouse in the foreground, and dramatized by sunlight filtering in between the posts on the viewer's left. The sunlight catches not only the various wooden shapes, but even illuminates a cloud of dust and what appear to be wisps of straw on the upper level of the warehouse. (Photograph courtesy American Artist.)

If this method is too difficult, try it in two paintings, commencing the second before the first has quite dried. The first attempt is almost certain to result in one serious blunder—the exaggeration of tone distinctions in the darker portion of the picture. The masses of tree are decidedly darker than the surroundings, mainly on account of the large number of black lines. Before these lines are drawn the contrast between the trees and the ground is one of color rather than of tone. Here and there the trees are lighter. This is the main fact to bear in mind while painting.

The outlines will require a very fine pen for the sky and distance and a broader one for the remainder. The power of indicating undulating surfaces and crowds of trees of various shapes, just as an etcher might do, will depend on understanding that can only come from continuous observation.

Discipline of Wash and Outline Technique

This method, like that dealt with in the previous chapter, was a favorite with the old watercolor masters, and many fine examples are to be found in public galleries, and reproduced in various publications. They should be studied with the greatest care.

Of late years, after a long period of comparative neglect, several applications have returned to favor among the modern schools, partly as a reaction against the prevalence of degenerate inefficiency, but mainly out of a recognition of its power to emphasize structure, solidity, and design. As a corrective to sloppy, superficially attractive "artistic" sketches, devoid of solid facts, the method may save many a student from a still common danger. Indeed, it would often be a good test of the value of a sketch to go over it with a pen and see how much of it could be resolved into exact form. Used, too, in tone sketches to accompany color notes, the method should be of the utmost service, especially when the finished picture is to be done on a much larger scale.

Using Photographs

Many exercises for gaining facility in the method indoors will readily occur to anyone who is keenly interested. Here is one: Take a photograph of a subject consisting largely of trees and woods. Sketch the masses in pencil and indicate the disposition of light and shade. Paint the whole in the manner suggested earlier in this chapter, and when it is dry, add outlines from the photograph until the required effect is obtained.

A few studies of this kind, though probably of little value in themselves (and perhaps dangerous if often repeated) will serve to give the beginner a measure of knowledge, facility, and confidence with which to tackle a similar subject from nature.

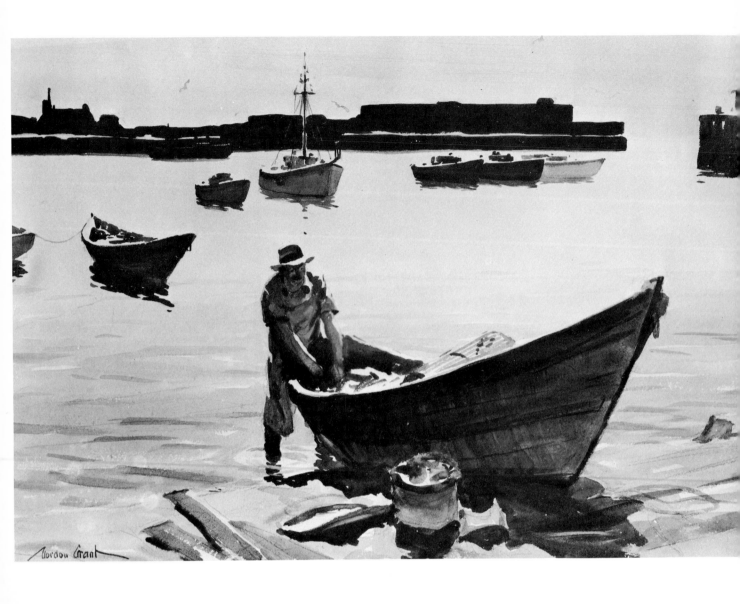

A MAN AND HIS DORY by Gordon Grant.

The mastery of watercolor painting begins with the mastery of values. Here is a particularly striking instance of the way in which intense sunlight can almost eliminate halftone and reduce values to sharp distinctions of light and dark. Everything here is virtually in silhouette and the artist has wisely reduced all his shapes to patches of flat color. The distant wharf, for example, is literally two strips of darkness with a light break between them, where the sun strikes. The water is flooded with light and carries only a pale wash of color which is uniform until we reach the foreground, where a few strokes indicate the movement and texture of the water. The painting of the foreground boat is particularly interesting because there is actually so much detail within the shadow. In the same way, the artist has roughly indicated the features and the folds on the figure, without becoming involved in finicky touches. It is also instructive to see the economy with which the reflections beneath the boats are painted. (Photograph courtesy American Artist.)

chapter

six

TRANSPARENT
WASH ON
WHITE PAPER

THE SIMPLE STUDY *The Spanish Gateway,* shown in two stages in Plates XVIII and XIX, illustrates the next step in technical difficulty and approaches to literal representation. Outlines are disregarded and full reliance is placed upon the wash.

Flat Washes

(1) Stretch or mount a half sheet (15"x22") of coarse-grained paper, preferably thick, and make a clear, thin outline in pencil.

(2) Mix (in a saucer) a quantity of yellow ochre with a little light red, sufficient to cover the whole surface except the white donkeys and the one seen through the doorway.

(3) Sponge the whole surface with clean water and press with blotting paper till nearly dry.

(4) Use a very large brush and take a flat wash over the wall; add a little rose madder when painting the ground. (If the wash dries with a positive edge round the doorway it will only serve to heighten the sunlight effect.) When this wash is thoroughly dry, lay a pale yellow wash on the houses and a slightly gradated wash of cobalt for the sky. Before the latter dries, drop a little green on the left-hand side and let it run into the blue. While these two washes are drying, mix a wash of deep gray, ultramarine blue, light red, and a little yellow for the darkest shadows.

(5) The complicated shape of the shadow around the doorway demands careful and speedy manipulation. As the prime necessity is to keep the whole wash wet at the same time, lay the paper flat and cover the whole space with water. Add a little pale gray to the water to see that the correct shape is covered.

Then take the dark gray wash into the wet space very quickly with a large brush. Before it dries, drop in a little green or brown here and there to give variety to the shadow. Tilt the paper to let these additions run slightly.

(6) Let the wash dry in a horizontal position and with hard edges. The smaller washes should not need preliminary damping. When these are dry, paint the roofs with varied washes of yellow ochre and rose madder. The remainder of the first stage should need no detailed explanation.

The second stage (Plate XIX) consists for the most part of intermediate washes, modifying the extreme contrast between both tone and color, and between the highlights and the deep shadows. Mixtures of reds, blues, and yellows in various proportions, painted in most cases quite crisply, will secure the desired result. This done, there remain only the details of the figures, the dark touches in the carving over the gateway, and a few details which need not be particularized. It will be noticed that a figure has been added to the group. This was not left, deliberately, for treatment in the second stage. It was an afterthought, and its need only became evident after the rest of the painting had been completed. Also a few passages had to be wiped out—part of one of the donkeys and some lights on the gateway. This also was not part of the original scheme. Both are examples of little alterations and corrections due to insufficient care and foresight.

Washing Down Unevenly

The remarks upon washing down in Chapter Two might well be applied here to all stages except the final washes. Subtle effects of gradation and texture could be obtained by painting the larger washes considerably stronger than required, and washing them down unevenly. Use a bristle brush, where necessary, to get the required roughness.

Trace the drawing and transfer the outline to a piece of thick, coarse handmade paper. Lay a strong wash of yellow ochre on the wall and ground. Wash it down unevenly as desired. Superimpose a wash of rose madder. Wash it down unevenly. Treat the roofs in the same manner. Proceed in this way several times if needed. But paint the sky, the shadows, and the other details in the same way as directed for Plate XIX, because washing out is bound to obliterate the essential sharpness of edges demanded in all these cases.

This method, with slight modifications, is perhaps the most popular with present-day painters, and the student would be well advised, at this stage, to take every available opportunity for studying such pictures in exhibitions or the excellent reproductions appearing in books and art magazines. It will then be noted that the method is particularly well suited to the representation of positive effects of strong sunlight where the main interest is in the foreground, rather than to subjects characterized by vague subtleties.

Drawbacks

There is no doubt that the strength of opaque watercolor painting can be attained in transparent washes in the hands of a competent artist. Lack of control in handling transparent washes is fatal if the student wishes to achieve

a convincing result. Naturally, there is a larger range of tones when white paper is chosen; and the darker the color of the paper, the less variety of tone can be painted on it.

The danger of working on tinted paper with transparent washes lies in the easy victory for the artist, since the range of tone values is retricted by the tone of the paper. On the other hand, some painters who habitually use white paper, and whose work looks fussy and unconvincing in artistic statement, would do well to practice pure washes, say on a light, warm, gray paper. The underlying tinted paper, undoubtedly, harmonizes all opposing colors painted over it, and many exercises of this sort—for a short period—are not only exciting to the painter, but most encouraging in the easy results obtained.

Herein lies the danger to the artist. The alluring ease of limited success is so comforting, that instances have been known where the student has finally abandoned the sterner problems of transparent color washes on white paper.

The Drawing is Essential

The picture entitled *A Street in Chioggia, Italy*, is shown in two stages (Plates xx and xxi). It is obvious that a picture of this type cannot be undertaken without mature consideration being given to the correct foundation of all transparent wash pictures, i.e. the drawing.

The material used consists of white paper with a canvas-grained surface. There are two varieties—fine and coarse. The one chosen for this purpose is a fine-grained surface.

It always pays to make the original drawing on a piece of ordinary paper. A cheap drawing paper answers the purpose, and all the problems of draftsmanship can be solved on the rough paper; after which the drawing is easily traced on to the watercolor paper. In the first stage (Plate xx), transparent tracing paper was placed and thumbtacked over the original drawing. Waterproof India ink was used, and a very small sable brush for tracing the outlines. After the ink was thoroughly dry, some soft charcoal was rubbed over the whole of the back of the tracing paper, and precisely the same procedure was adopted as advocated for the preliminary drawing of Plate xvi.

Accuracy and Precision

It is delightful to commence transparent or pure watercolor painting on a surface that has not been mauled with incorrect lines or dirt smudges. The laceration of the paper by a too generous use of the eraser is not helpful towards attaining a good technique in watercolor painting.

The student who wishes to copy the first and final stage of this street scene will do well to procure two large jars filled with fresh water—anything of an egg-cup size is practically useless for clean, incisive painting. Also half a dozen saucers, together with a well-assorted range of sable paintbrushes, and not forgetting a good supply of colors; then last, but not least, a small sponge and unlimited quantities of blotting paper. A small bristle brush (one that has not been used for oil painting) about ⅛ in. wide, or a little larger, is very useful for washing out minute highlights. The blotting paper is applied immediately after the washing out by the oil brush, as well as after sponging out.

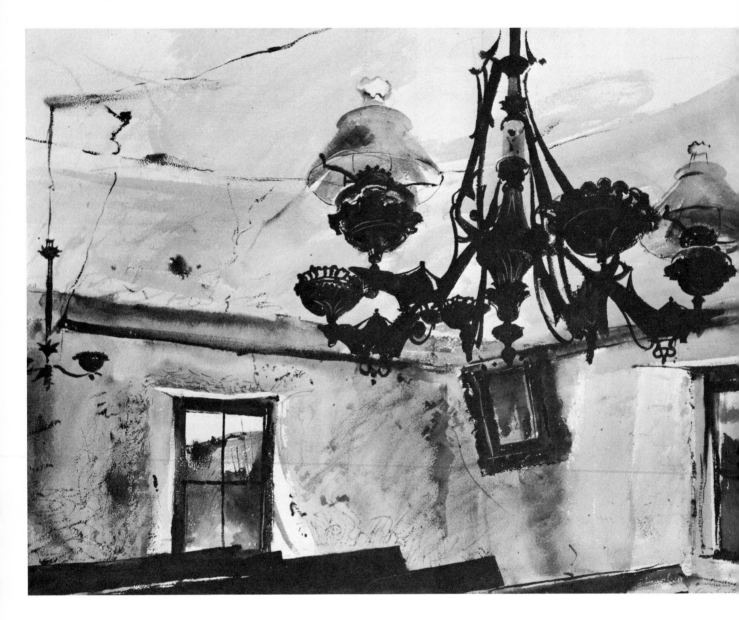

CHANDELIER by Andrew Wyeth.

The artist has discovered the fascination of an unlikely subject in a unlikely composition. The dramatic, intricate shape of the chandelier is placed against the barren, moldering walls of the old building. The chandelier is painted with extremely direct strokes of dark paint, modified here and there by a light scratch for a touch of detail— probably the effect of the brush handle or a finger-nail in the still-wet paint. The surrounding walls are animated by scribbly drybrush strokes and blurry wet-in-wet effects. The brush appears to wander casually, but each note is carefully planned: for example, place your hand over the diagonal stroke on the ceiling in the upper left hand corner, and see how critical this is to the composition. (Photograph courtesy American Artist.)

Referring to the first stage (Plate xx) of *A Street in Chioggia, Italy*, great care was taken in painting the flat color washes representing light and shadow in their correct positions. In the preliminary painting, mechanical accuracy in pure color washes is essential as a foundation for the final artistic touches, including, of course, wiping out.

The white clothes hanging vertically downward represent the actual paper, being free from any color tints. The purple tints in various parts of the subject were made with a mixture of permanent blue and alizarin crimson. Yellow ochre and a little burnt sienna with plenty of pure water did service for most of the highlights toward the right of the buildings. Any greenish tint in the picture was made with viridian.

The figures grouped in the street were intensified in tone for two reasons: (1) to accentuate, through dark tones contrasting against light tones, the effect of sunlight on the buildings, etc.; (2) to help the sense of scale, since the small stature of the figures assists in giving a proportional height to the surrounding houses.

The bluish-colored wall shadow (immediately above the two centrally-placed women with the baskets) was made with cerulean blue mixed with a little purple. Cerulean blue, when mixed with a touch of another color, produces excellent tints.

Plate xxi shows the finished picture. The sky and highlights are deeper in tone. In most parts of the painting, the colors were painted in with strong tones, so that the small sponge could wipe out with decided effect the patches of halftone and highlights. For some of the highlights, a clean sponge was used three or four times, pressed gently, but firmly, on the tinted paper. For halftones, one application of the sponge was sufficient. All sorts of subtleties can be achieved with the sponge method of wiping out.

Better than any other method of study is the privilege of seeing a competent artist at work. More can be learned from a single demonstration than from chapters of written description. And if, in addition, pictures in various stages of completion can be examined, the observant student should carry away a host of invaluable hints. It is a great pity that the practice of the demonstration by masters of technical methods is exceedingly rare.

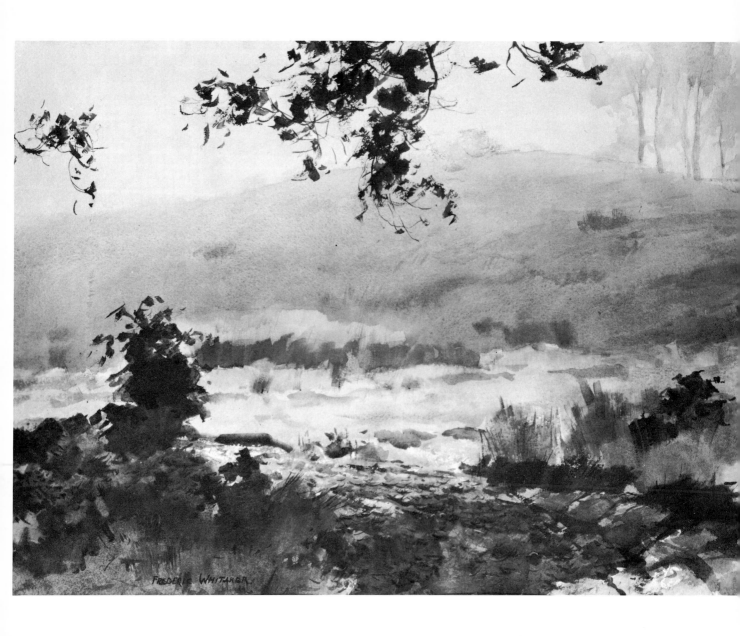

FOGGY MORNING by Frederic Whitaker.

The subject of this painting is the atmosphere itself. By an extremely knowing control of values, the artist has divided the picture into delicate planes of light and dark which create a strong sense of space and a feeling for the weather. The nearest plane is the darkest, of course, followed by a middle ground which receives a certain amount of light—the only hint of real light in the picture— followed by the distant gray shape of the landscape, melting into the gray sky beyond. With a minimum of landscape details, the artist has created a com- *plete landscape and a complete sense of time and place. Perhaps the most interesting element in the picture is the cluster of foliage that drops in from above and is echoed by a similar cluster at the left; these suggest an even nearer plane than the dark foreground and have the effect of thrusting the distant landscape even further back in space. Try an experiment: cover this hanging foliage with your hand and discover for yourself how crucial this element is to the success of the painting (Photograph courtesy* American Artist.)

chapter

seven

TRANSPARENT
WASH ON
TINTED PAPER

THE PICTURE ENTITLED *The River Doubs, near Besançon, France* (Plate XXII), is an example of transparent wash on a tinted surface. The tint of the paper is clearly seen in the sky, which was allowed to retain its natural tint, without any sort of color being used to destroy its flat serenity.

Detail

The intention of the artist was to obtain as much detailed information as possible in an outdoor sketch. There was no striving to obtain fleeting effects of light and shadow. Clouds would be of little value in a sketch of this type as the subject is essentially a winding river flanked by fields and adjoining hills. A long time was spent in drawing the subject with and ordinary B lead pencil. There is nothing accidental in the drawing and painting. Notice how every house and cottage adjoining the farther bend of the river shows evidences of precise drawing, also the minute trees and lines in the far distance.

Accent

The middle distance from left to right (the hills with their contours silhouetted against the sky) was originally painted in the same open, detailed manner as the spotty effect of adjacent trees, fields, etc.; but as it was possible to bind it together by a flat wash of bluish gray, this color was then washed over the whole middle distance with the exception of the intermediate river. The picture thus gained that accented touch which keeps the subject from being dull, without in any way losing the detailed information so necessary in this complicated landscape subject.

Paper

Delicately tinted paper, like the color of this example (Plate XXII) is excellent to work on, without the aid of any opaque watercolor. The pure color of the paper helps each wash or touch of color that may be used on its surface. Thus, while freshness of color is easily kept, yet all the painting has a characteristic tone which is far more difficult to obtain when one is painting in pure wash on white drawing paper.

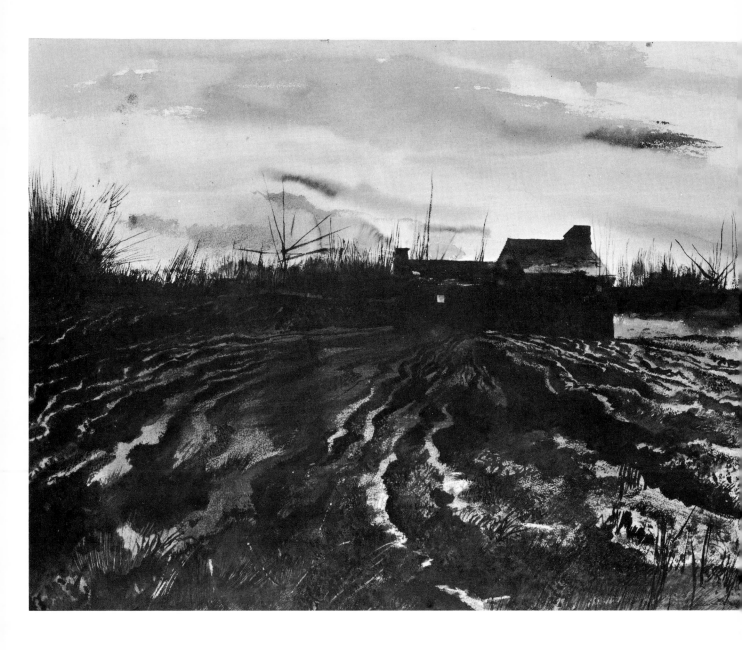

MARCH by Andrew Wyeth.

The light of the turbulent sky throws the building and the foliage along the horizon into dark silhouette. The edges of the furrows in the foreground pick up this light and create a swirling pattern that channels the viewer's attention violently toward the center of interest, which is the dark house with its single lighted window. Almost all of the landscape is in darkness, except for edges of light on the furrows and the lighted window, which becomes the "eye" of this stark composition. The *wispy strokes in the immediate foreground and along the horizon create the illusion that the landscape is rich in detail, although most of the picture is actually large, broad strokes, almost entirely devoid of detail. This sky is a fascinating combination of wet-in-wet effects and hard edges, none of which are accidental or static, and all of which give a sense of direction and movement to the clouds and to the wind. (Photograph courtesy* American Artist.)

chapter
eight

DRY METHOD
AND
SCRATCHING OUT

THE ILLUSTRATION in Plate xxiv illustrates the dry method, one much favored by the early watercolor painters, especially for skies.

Dry Method

Use a very coarse paper. After dipping the brush into the required color, shake out as much as possible. Hold the brush at a considerable angle so as to bring the side into contact with the paper. Move it very quickly and lightly, especially at the edges of the wash, so as to get the required roughness. By this means, an apparent gradation of tone can be obtained—darkest where the wash is solid, and lightest where it is roughest.

Scratching Out

It would be scarcely possible to carry out a preconceived idea in every detail by this method; the most proficient painter would be certain to need to make corrections. This can be done quite easily by scraping (scratching out) with a penknife. When this is done deftly, it should be difficult to see where the painting ends and the scraping begins. For long thin strips of cloud, such as the horizontal ones shown in the illustration referred to, scraping is by far the more simple and satisfactory way.

When to Use the Scratching Out Method

Two points need to be kept in mind: (1) the danger of abusing the method by overdoing the scraping, and (2) the need for painting the rest of the picture in the same hard, dry, rough manner.

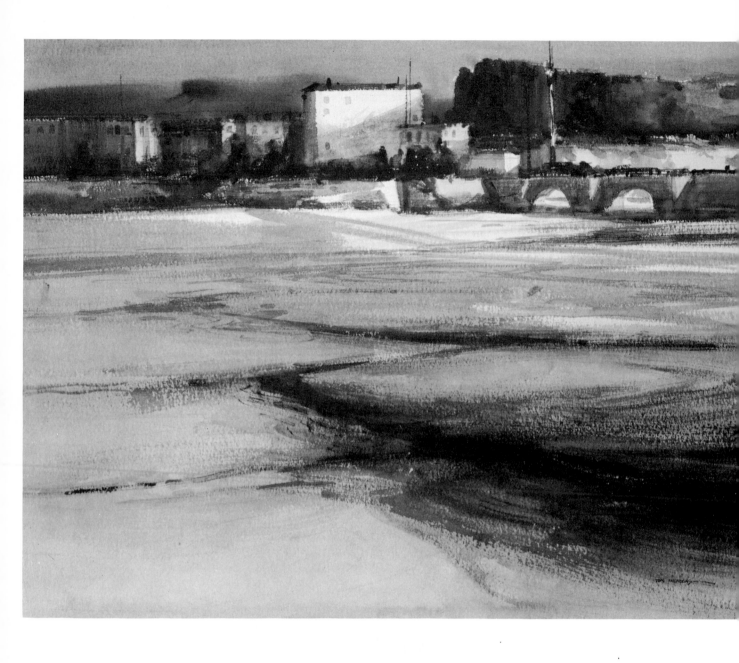

ACROSS THE RIVER by Tom Nicholas.

This is a particularly audacious composition because the artist has decided to devote three quarters of his picture area to the abstract pattern of the river bed and water at low ebb in the foreground. This creates a zigzag path which leads the viewer's eye toward the bridge and row of buildings far back on the horizon. The horizon line is extremely high in the picture. It is significant that nearly all of the landscape is in shadow, with a brief flash of light illuminating the largest building on the horizon and picking up a portion of the river and bits of other distant architecture. The strokes in the foreground are quite distinct and one follows them back almost as one might follow the lines of a map. See how little detail there is in the buildings themselves; only a few of the windows have been indicated. (Photograph courtesy American Artist.)

As illustrations of the abuse, as well as of the successful use, of this method, the old masters might well be consulted; for at one time the practice of scratching out trespassed beyond all reasonable bounds and degenerated to a vice. To all but the exceptionally strong minded, its insinuating ease is a temptation to sneak out of difficulties otherwise easily overcome.

Apart from the particular kind of clouds illustrated on the plate, certain classes of subjects justify the reserved and unobtrusive use of the method. Small patches of glistening light on waves and streams and waterfalls, for example, which could not be left when laying previous washes, may reasonably be scratched out. Lights on wet grass, roads, and stones, might sometimes make any other course impossible except by the use of opaque watercolor. Small white flowers might, in some cases, afford a justification.

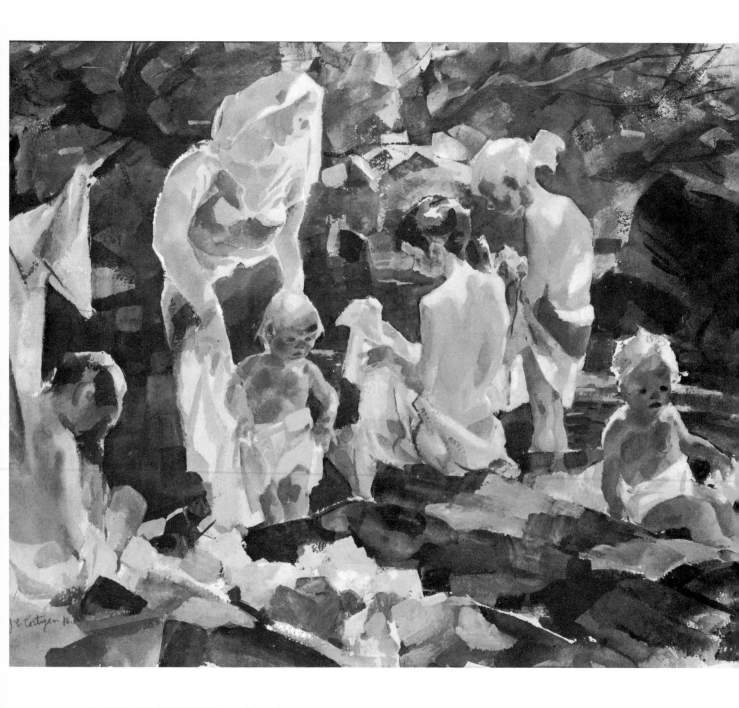

GROUP OF CHILDREN by John Costigan.

Faced with the complex problem of painting a group of figures in broken sunlight, the artist has visualized both the figures and the surrounding landscape as a mosaic of patches of light, shade, and color. These unpredictable patches are rendered with broad strokes of the brush, which sometimes flow into one another, sometimes remain flat and distinct. The paper, itself, is used for the brightest touches of light, where the figures are caught in intense sunlight; notice how the figure of the mother is edged in light where bare strips of paper *have been left between her form and the dark background. This picture is a particularly arresting example of transparent and opaque watercolor combined. The figures are generally rendered with luminous, transparent strokes, one patch of transparent color laid over another to build the figure. On the other hand, the foreground rocks appear to be strokes of thick, opaque and semi-opaque paint, giving a feeling of weight and solidity which contrasts effectively with the delicacy of the figures. (Photograph courtesy American Artist.)*

chapter
nine

PASTE
METHODS

PLATES xxv, xxvi, and xxvii demonstrate the use of ordinary flour paste in conjunction with watercolor painting. Each of these three sketches was done on heavy drawing paper. There is no opaque watercolor used in any one of the three examples.

How to Make Paste

It is a comparatively easy matter to make the paste necessary for the purpose of watercolor painting by this method. A couple of teaspoonfuls of ordinary flour can be put in a small pudding bowl, to which is added just enough cold water so that when the mixture is well stirred and ground with a spoon, a moderately thick, creamy mixture is obtained, but not so thick that it is unable to rest with a flat surface in the bowl. Next, pour boiling water slowly but steadily into the bowl, stirring vigorously and continually with the spoon until the paste becomes quite glutinous and thick. Too much boiling water will thin the paste so as to be of little use for the required purpose. When the paste is cold, it is ready for use.

How to Use Paste

There are two ways of using paste in watercolor painting: (1) dip the brush, either with or without water, directly into the paste and then into the color; (2) prepare the paper with a coat of paste with a flat, wide brush (precisely in the same manner that is adopted for gluing down a homemade luggage label for a parcel or trunk), then brush well so that a fairly thin coat is evenly spread out on the drawing paper and free from any suggestion of different thicknesses or lumps on the surface.

The sketch in Plate XXVII was done in the second way. After the whole of

the paper was covered with a coat of flour paste, various pure watercolors such as yellow ochre, cadmium, violet, viridian, and burnt sienna were painted directly onto the *wet* paste surface, in spontaneous color blobs, over the whole of the light portions of the quarry, and no consideration was given as to the ultimate structural form of the quarry. While the paint was still very wet, a square-shaped watercolor brush, quite free from any suggestion of color impurity and just moist enough for the purpose, was used for licking up the various color blobs. As the sketch clearly shows, this brush was used mostly in a vertical direction and pressed very strongly into the paint at each stroke of the brush.

Another point to take into account is the importance of washing the brush in clean water after each brushstroke, and then squeezing out most of the water.

It is interesting to observe how the shadows (suggesting more or less structural forms) are caused by the colors left undisturbed by the absorbent paintbrush. The lightest parts of the sketch demonstrate the fact that the clean paintbrush has taken off nearly all the color that may have happened to be there in its original state.

Characteristics of Paste

A most interesting feature in this method of painting, whether on a prepared surface of paste, or with the use of paste directly with the paint, is the way in which the paste holds the watercolor and prevents it from spreading about in an unruly manner. In this respect, there is a certain similarity to oil painting which, when used in a normal style, shows a well-defined brushmark on the surface of the oil pigment. The sketch in Plate XXVI bears a strong resemblance to the textural surface of oil paint brushmarks. Here the slightly damp brush was put directly into the paste and then mixed with the purple tint before any painting was done on the drawing paper. The well-defined streakiness or brushmark contours are easily rendered when the color is used with mostly paste and very little water.

The top sketch in Plate XXV was painted with a little paste mixed with plenty of water. The color, like transparent wash painting, spread with ease on the surface of the paper. To obtain the brushmark in this sketch, the same brush—already charged with color—was laid flat on the painted surface, and pressed firmly over the ferrule end of the sable hairs, this pressure causing the light spot to appear at the foot of each brushstroke. These three examples of the uses of paste were all done while in a wet condition, as regards both paste and color. In the sketch in Plate XXVI the deepest tint was added in the higher portion after the rest of the sketch was completed, but before drying.

Experiment with Paste

Students are advised to practice with boldness, on fairly smooth paper, a number of exercises in the handling of paste. Use also paste of varying thicknesses. Trees, cottages, rivers, and especially mountains showing some form of rock strata, are all ready to be experimented with in this style of handling. Generally the easiest way is to prepare the paper with a flat coat of paste,

and to paint on that with pure watercolor in the method previously described.

There are, of course, many possibilities in paste methods for expressing different styles of landscape painting. Powerful mountains of deep-toned tints can be expressed as readily as delicate, light misty subjects. The intelligent student should try many ways of expressing varying landscapes and figure subjects. There is no doubt at all that many textural surfaces can be obtained with the aid of paste.

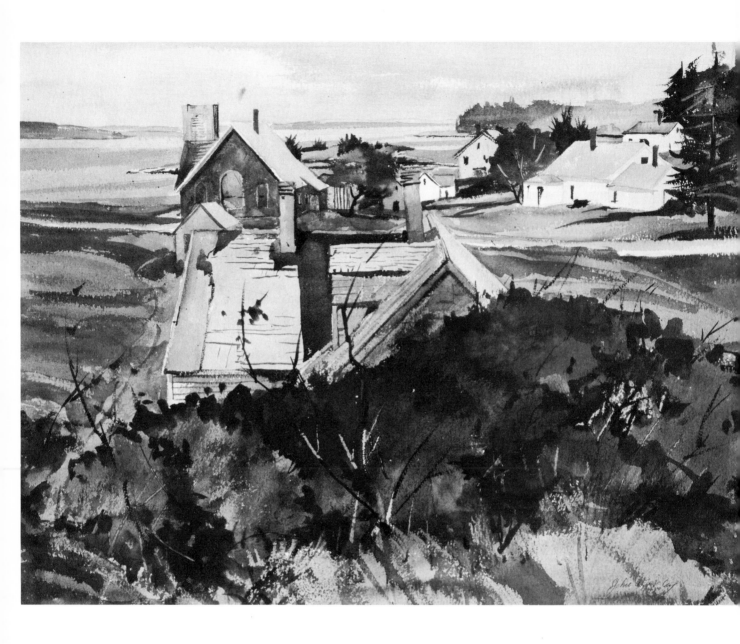

VILLAGE BY THE SEA by John McCoy.

The distinguishing characteristic of this watercolor is the vitality of the brushwork. Everything appears to be "dashed in," and there is no evidence of the great amount of planning which is actually necessary to produce such a successful watercolor. This is, in fact, the secret of the medium, which must always look spontaneous, no matter how much planning is really involved. Throughout, the sweeping strokes are enlivened by the roughness of the paper, which constantly breaks through the color and creates a drybrush feeling even when the color is quite fluid. The artist has gone back into the still-wet color with a tool—perhaps the brush handle or a knife—to scrape away strokes of light on the branches in the foreground and the distant trees. Study the variety of strokes, each appropriate to the subject: the long strokes for the flat ground; the short, dabbing strokes that overlie the mass tones of the trees; the thinner, drybrush strokes for the nearby buildings; the sharp, sudden strokes for the notes of dark on the distant buildings, etc. Such strokes are made quickly, but are planned with great precision. (Photograph courtesy American Artist.*)*

chapter

ten

SCRAPING OUT
PROCESS

T HE EXAMPLES ILLUSTRATED in Plates XXVIII and XXIX were done on fairly thick drawing paper. Each illustration is based on the same method of using an ordinary penknife.

How to Scrape Out

Holding the blade about an angle of 30° to the paper, and scrape with a firm pressure parallel lines or curves at any convenient angle. The paper should be so placed as regards light that the student will be able to clearly see the direction of the scraped lines. It is better to move the knife fairly quickly for each stroke of the blade, so as to obtain a definite line of equal degree of incision. Next, use some liquid color, such as yellow ochre (mixed with plenty of water) and, with a fair-sized brush, paint a flat wash over the whole of the scraped lines. At once there appear two tints of yellow ochre. The scraped portions of the paper cause a great deal of its surface to be slightly raised, and each raised portion (through the effect of light) casts its own innumerable little shadows.

Value of Scraping Out

The colored diagrams in Plate XXVIII illustrate the effect of various colors when washed over parallel scraped lines. Diagram B suggests the feeling of flowing curves, while the old cottage walls convey the value of knife scraping from a textural standpoint.

The illustration in Plate XXIX proves the effectiveness of scraped lines for representing the bark on tree trunks. It is surprising how simple it is to wash transparent colors on drawing paper which has been previously prepared by scraping the surface with a penknife. Notice, for instance, how effectively a tree trunk can be rendered with scraped lines. As each color was applied, two colors appeared, the darker tint in each case giving the suggestion of the bark growth, and harmoniously blending the greens and browns without loss of decision in the detailed forms.

It is important always to bear in mind that all scraped lines, curves or dots, should structurally assist the following color washes and in no way detract from the fundamental growth of the sketch or picture. Pure transparent color washes painted with a very wet brush are essential if the student wishes to achieve success. Any drawing paper used should be of a fairly smooth surface.

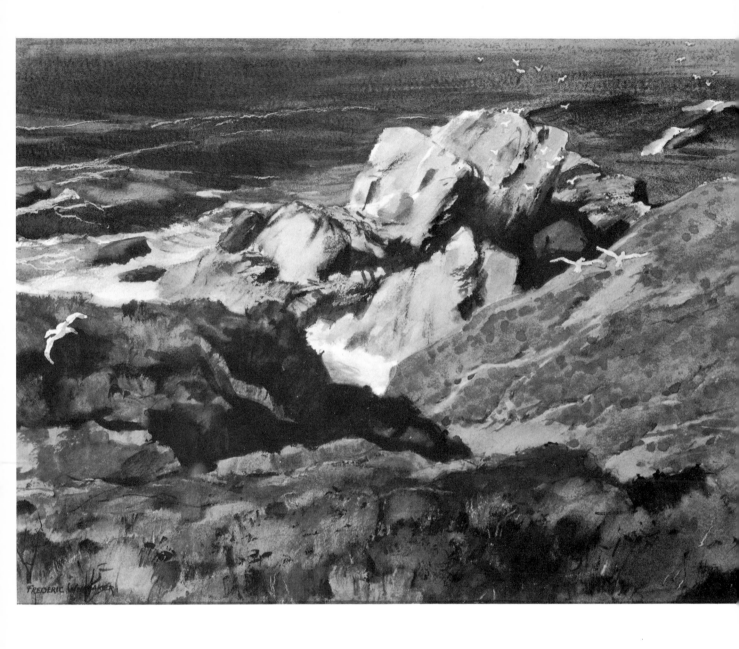

CALIFORNIA COAST by Frederic Whitaker.

Although rock formations often seem confusing at first glance, they do simplify themselves if you visualize rocks as geometric shapes that have planes of light and shadow. Here, the artist has focused the viewer's attention on the central cluster of rocks, which are caught in an intense flash of sunlight, dividing them into planes of brightness and deep shadow. However, it is important to note that even the lighted sides of the rocks are not *mere white paper, but carry a variety of delicate tones and textures. The darkness of the sea beyond throws the lighted rock formation into relief. The artist has also placed the foreground in shadow, framing the central rock formation, rather than distracting the viewer's attention from it. Observe the lively drybrush and wet-in-wet touches in the immediate foreground. (Photograph courtesy American Artist.)*

chapter
eleven

CHARCOAL AND WATERCOLOR

PLATE XXX SHOWS two vertical bands of purple on the top left and right, both representing a pure wash of exactly the same tint. The example on the left is painted direct on the pure paper. The opposite example on the right was prepared with charcoal shading, and then sprayed with fixative. Notice the difference of tone in these two demonstrations.

Fixed Charcoal

Colors washed over fixed charcoal drawings do not disturb the outlines or shading below. The two lower drawings in Plate xxx were also fixed before painting was commenced. Charcoal is often a help in architectural subjects, particularly in ancient buildings where the masonry shows crumbling surfaces. It is important to remember when painting in watercolor on a prepared charcoal drawing that the color should be much brighter and purer in tint than is usually the case when washed over a pencil drawing. The depth of tone, or density of charcoal, tends to neutralize any bright color washed over its surface.

Unfixed Charcoal

The charm of unfixed charcoal is seen in the partial blending of watercolor with the charcoal. Evidence of this is shown in the top middle sketch in Plate xxx. Provided that the charcoal drawing is sound in construction and not too solidly used, and that dense patches of black surfaces are avoided, color can be washed over without losing the original drawing. A large, square-shaped brush, not less than ½″ wide, should be used when convenient, in preference to a small paintbrush which only tends to disturb the charcoal beneath. In studies of this sort, the unfixed charcoal, immediately coming

into contact with the watercolor, becomes absorbed more or less into the watercolor tint, and thus any likelihood of hard edges showing in the various forms depicted in the painting is minimized.

Practice is Required

The use of charcoal with watercolor painting is not easy and requires constant practice. A muddy result is painful to behold. Indecision of handling leads to tragic results. Students who have had little experience in charcoal painting are advised to do many exercises with a sparing use of the medium until confidence is gained by success, after which it is a fairly easy road to the stronger stages of charcoal handling.

WYOMING TRAIL by Gerry Peirce.

In order to simplify and organize the possible confusion of a woodland interior, the artist has divided the tree trunks into near and far by painting them in various gradations of gray, ranging from quite dark to the most evanescent possible tone. The viewer also looks through the trees into the lighted sky beyond. Detail is used selectively, with the growth in the foreground indicated precisely, while the foliage on the trees themselves is rendered as a series of blurs of more or less flat color. The fallen tree trunk in the foreground relieves the generally vertical feeling of the growing trunks, as do the smaller tree trunks of the younger growth. (Photograph courtesy American Artist.)

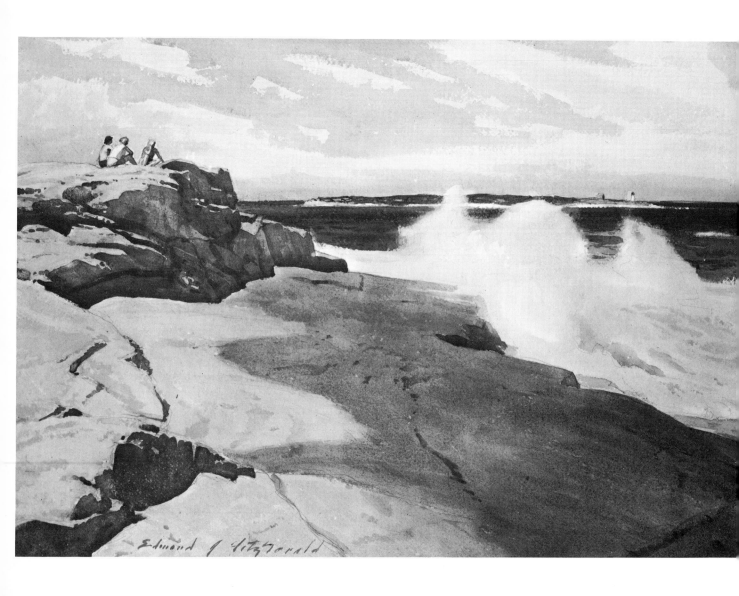

BREEZY AFTERNOON—ROCKPORT
by Edmond J. Fitzgerald.

This is an interesting example of the use of cloud shadows to control composition. On the massive rock formation in the immediate foreground, a large shadow is cast by an unseen cloud above— thus helping to dramatize the light tone of the splashing foam just beyond the rock. The foam is also framed by the darkness of the water beyond. The shape and direction of the cloud shadow is echoed in the moving clouds above, which have the same character as the shadow. It is always important to remember that clouds are not merely patches of color, but do have a direction deter- *mined by the prevailing wind and by weather conditions. Here one senses the direction of the wind very strongly, not only in the clouds, but in the foam, which blows in the same direction as the clouds. The landscape painter in watercolor—or in any medium—must learn to study weather conditions and must remember that such elements as wind affect all the components of his picture. All too frequently, a beginner will make the mistake of painting clouds which move in one direction and trees which move in quite another! (Photograph courtesy American Artist.)*

chapter
twelve

GRANULATED WASH

M ANY PAINTERS in watercolors are aware that some colors occasionally dry unevenly—in a series of blobs of solid color which gives a mottled effect—but few know exactly why. Nor do they know how to control the action, that is to say, to secure it or avoid it at will. This is one of the most fascinating and least understood branches of watercolor technique, and will well repay thorough inquiry. To those who are looking for extensions of power over the medium, the results will have all the wonder of the revelation of a deep secret.

How to Lay a Granulated Wash

(1) Take a piece of heavy, coarse-grained cold pressed paper, mounted on thick cardboard, and fix it firmly to a drawing board so that it will not warp in the slightest degree. An absolutely plane surface is essential.

(2) Give it a wash of pale orange, weakening towards the top of the paper. Leave till quite dry. Mix a considerable quantity of cerulean blue in a saucer—about twice as much as would be required for an ordinary flat wash.

(3) Place the drawing board at a slope of about 15° to the table. Take a large wide brush capable of holding a great deal of color; charge it fully and draw it across the top of the paper so lightly that the hairs scarcely touch the paper. Add a brushful of water in the saucer and extend the wash by another stroke. Repeat the process as quickly as possible till the paper is completely covered.

(4) Immediately after this is done, lift the board to an angle of about 60°, when the wash begins to run down; then tilt the board in the opposite direction and the wash will run back. Do this several times and note how the pigment separates into solid spots, leaving spaces of clean, or almost clean,

paper between, while the water has separated from the pigment. When the pigment does not move with the water, let the water drain off, place the board at the same angle as when the wash was painted, and leave to dry.

The method described above is how Example D in Plate XXXI was painted. It will be noticed that the spots on E of the same plate differ considerably from D, being larger and less decided in shape. This softer effect was obtained by omitting to drain the water and by laying the board quite flat while drying.

A little practice will soon prove that the paler the wash, the simpler the process, and that if there is not water enough to keep all the pigment moving at the same time, the wash will not have a regular gradation.

Once the method is mastered, it can be made to produce surprising results, particularly in cloudless skies. It is doubtful whether the sense of vibration in D could be obtained in watercolor by any other means.

Reaction of Pigments in Granulated Wash

To those who see in this method desirable possibilities of extension, the simple illustrations in Plate XXXI will be regarded as preliminaries to an intensely interesting course of investigations. It will be found that very few pigments act in this way, and each of them acts in a slightly different way.

Several pigments, such as Antwerp blue and vermilion, do not separate at all. Examples E and F in Plate XXXI illustrate this fact quite dramatically. They were painted on the back of a piece of wallpaper with a coarse grain composed of little pits. In E, the emerald green flowed into the pits and formed solid masses of pigment, leaving the rest of the paper with a very pale wash. In other words, the pits were filled with masses of particles close together, but the raised parts were left with a few separated particles. But in F, the vermilion insisted upon covering the whole surface quite evenly like a stain. Thus, it happened that when the emerald green was painted on the vermilion, the result was a series of pure emerald green separated by a brownish color made by the combination of strong red showing through the thin wash of green. But when the vermilion was superimposed on the emerald green, it resulted in an almost flat tint of brownish red.

Experiment with Granulated Wash

As the experiments proceed, pictorial applications will inevitably arise, and might well be tried as they occur. For instance, the painting of a picture in colors that will be corrected and completed by a final wash of cobalt blue contains the germ of considerable possibilities.

Examples A and B in Plate XXI are still more curious and suggestive. Each was painted on the same kind of paper (coarse-grained, cold pressed), and with the same colors, emerald green and rose madder. In A, a wash of rose madder was first laid on. It separated, but not so much as emerald green would have done. When quite dry, the emerald green was superimposed and separated into patches, maintaining its original color. In B, the paper was made quite wet and the two colors were dropped in together. This time, a more decided unevenness resulted, but the original colors were not maintained

The three figures on the left of Plate XXXII (A, B, and C) carry the investigations a step further. A is a flat wash of vermilion which would not separate. B is a gradated wash of cobalt blue on the vermilion, giving a purple. In C, a gradated wash of emerald green is added, resulting in a subtle gray, composed of green, blue, and pink spots.

It will now be seen that if this method is to be perfected, the action of each color must be tested individually and in conjunction with all the others. When this has been done, the inquirer will be provided with a new and almost unexploited means of expression, which, if suitably applied, might revolutionize his painting.

All the successive steps cannot be detailed here, but the following suggestions will serve to indicate the general direction which the reader's investigations might usefully take.

(1) See what can be done, on papers of various surfaces, with cerulean, cobalt blue, emerald green, cobalt green, and rose madder, and any other color that will separate, however slightly.

(2) Try combinations of these colors on the same papers.

(3) Try each color and combinations on prepared grounds.

(4) Note, while experimenting, how practical purposes might be served, and apply pictures whenever possible.

Those rare painterrs, exceptionally endowed with a decorative sense allied to the enviable ability to seize sudden and fleeting suggestion, will find in this method a source of never-ending delight. Accidental combinations will often take fantastic forms that would never occur to the most imaginative.

Eccentric Colors

Take a sheet of the coarsest handmade paper which has been pasted to a thick board. Fix it firmly to a drawing board with tacks so that the edges will not turn up. Then lay it absolutely flat on a table. To make certain, test with a level. Now take any colors which have behaved in an eccentric manner and pour them on the papers in various strengths and quantities. When the paper is covered let some large drops (or a tiny stream) of pure water fall from a height of 2' or 3' and splash into the color. Lift the drawing board, tilt it at various angles, and let the colors run as they will. Take off some color here, add a little there, as pleases the fancy. The chances are that vastly interesting things will happen—charming, unexpected conceptions born by accident. In any case some parts will be almost certain to suggest how the method can be used in some deliberately designed subject. Gray stains on old buildings, textures for foregrounds, and walls, falling rainclouds, quaint patterns—these and many other things may occur on the same sheet of paper, and may some day prove more useful than as many laborious sketches. And if an addition—Chinese white—is made, the suggestions will multiply prodigiously.

The illustration shown in three stages in Plates XXXIII, XXXIV, and XXXV is an application of this method, and also serves to indicate how the use of other

methods is sometimes compelled by circumstances. In this case, the picture was a large one, and the dots of blue in the sky are rather large as the paper was exceedingly coarse in grain. This sky was done in a few minutes, on a previously painted ground of pale orange. A great deal of water was used, so that the whole surface remained very wet until it was finally drained off. Such a method could not be applied to the rest of the picture, as each layer has to keep exactly within certain limits of space, and less water had to be used lest it overflow during tilting the paper. Consequently, the granulation was not so pronounced as in the sky, which, by comparison, looked coarse and spotty. It became necessary, therefore, to paint in actual dots here and there in the final stage of the picture.

This necessity had an influence on the choice of subject. Many subjects could not be satisfactorily treated in painted dots. These had to be ruled out, and one chosen from among those suitable to such treatment. Lights on rippling water, breakers, trees with many leaves that show separately, are examples of features which could easily be treated in a way that would harmonize with this sky. But a large expanse of smooth surfaces would emphasize the spottiness of the sky, and turn an effect of vibration into an irritating form of distraction.

The method is better suited to large pictures, because the larger the number of spots the less they will show as separate spots. But there are several other adaptations possible which can be applied to quite small pictures. The method can be applied to parts of a picture and not to others. For example, the sky might be painted without any granulation, while the grass, trees, roofs, old walls, etc., might be decidedly granulated.

Granulated Wash over Completed Painting

Another plan, capable of fascinating effects, is to paint the whole picture (except perhaps the final touches) and then, when the picture is thoroughly dry, carry a pale wash of granulating gray over the whole surface. This is not a simple matter unless none of the colors can be very easily dislodged, and in any case the wash would need to be laid on with exceedingly delicate handling. The brush should be very wide, very free of color, and, if possible, the hairs should scarcely touch the paper. It would be necessary, of course, to initially paint the whole picture rather lighter and brighter than would otherwise be done, because the gray wash will modify every color underneath.

Test your Pigments

The successful application of this method calls for a good deal of careful inquiry into the properties of the pigments in order to discover (1) what pigments are less easily dislodged, and (2) what pigments which produce gray when mixed will granulate. To take a few examples: rose madder comes off all too easily because it remains on the surface of the paper; but alizarin crimson penetrates the paper like a dye, and will withstand a considerable amount of over-painting. Anyone who wishes to perfect this method, therefore, should test each pigment when applied at various strengths, and discard

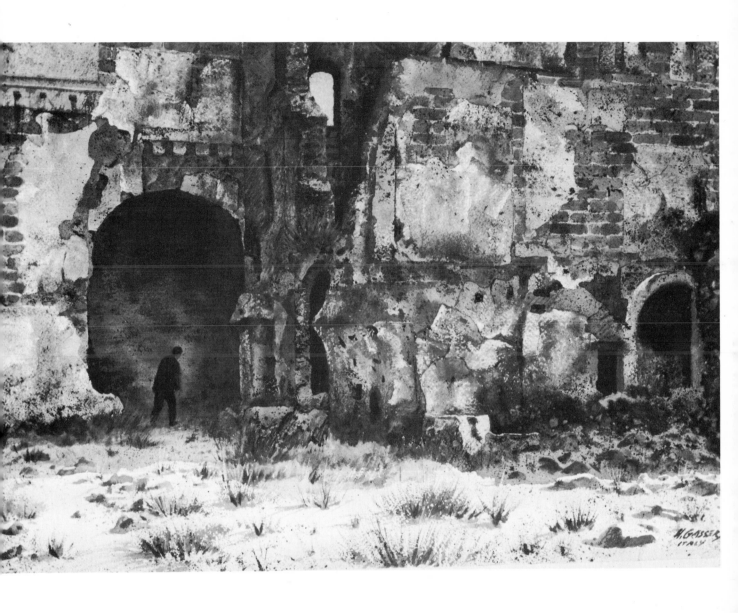

LONELY WALK by Henry Gasser.
The intricate and varied textures of the broken wall, with its exposed brickwork, are rendered in a fascinating combination of techniques. Examine these areas of the picture carefully and you will see granulated washes, drybrush, spatter, and wet-in-wet effects. This extraordinary variety of technical effects is carefully controlled by the composition which breaks the wall into clearly defined areas that form a satisfying pattern. (Photography courtesy of the artist.)

all pigments which are likely to become dislodged. It will also be found (and this is a very important point) that most, if not all, pigments adhere to the paper more firmly after a lapse of time; they tend to sink into and become part of the paper. Generally, it will be advisable to paint the final granulated wash two or three days after the previous painting has been finished.

To produce a granulating gray it is not necessary that all the component colors need be of granulating pigments. Here, again, accurate investigation is essential. It will be found, for example, that Prussian blue will have to be avoided in any mixture, while cobalt blue, mixed with most other pigments that together produce gray, will effect a certain amount of granulation. The whole field of possibilities in this aspect of watercolor has never been completely explored, and it is certain that considerable systematic experiments would put the inquirer in possession of very valuable information.

Plate I. A Midday Sky *(first stage). A simple way to paint a sky is described in Chapter Two. This plate shows the result of painting a wash of yellow ochre with a superimposed wash of rose madder.*

Plate II. A Midday Sky *(second stage). This plate shows the effect of a wash of cobalt blue painted over the sky illustrated in Plate I. The simple landscape was painted with the same colors as those used for the sky.*

Plate III. An Afterglow *(first stage). This plate illustrates the same method of painting a sky as is seen in Plate I, using cadmium yellow and vermilion for the first and second washes completed by a wash of cobalt blue.*

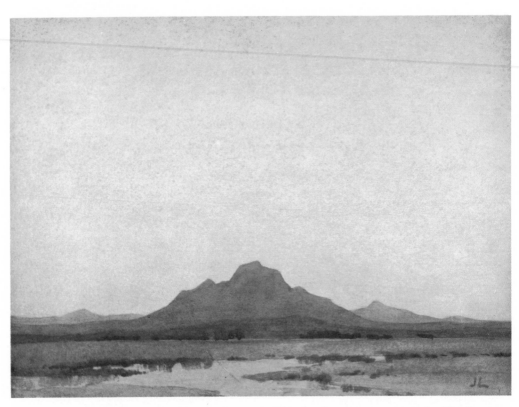

Plate IV. An Afterglow *(second stage). This landscape was painted with the same three colors as the sky in Plate III. A detailed description of the method is given in Chapter Two.*

Plate V. Superimposing the Primary Colors. *This plate and the following one (Plate VI) show the possibilities of combining three contrasting colors—yellow, red, and blue—and should be regarded as a starting point for further experiment on the lines suggested in Chapter Two. The method is fully described in Chapter Three.*

The student should discover, at an early stage, the different results obtained by mixing and by superimposing the same colors. These differences are due, mainly, to the varying degrees of opacity in some of the so-called transparent colors. Experiments with yellow and blue will prove, contrary to popular opinion, that the purest colors, when mixed or superimposed produce the least green. Perfectly pure blue and yellow would give no green at all!

In this demonstration, the primary colors are superimposed in the following order: (A) yellow superimposed over (from left to right) blue, yellow, and red; (B) red superimposed over blue, red, and yellow; (C) blue superimposed over red, blue, and yellow.

Plate VI. Mixing the Primary Colors. *Here, the three primary colors are combined by mixing. A shows the contrasting colors full strength; B shows the colors diluted with water, resulting in faded and delicate color tints. See Chapter Three for details.*

Plate VII. Superimposing the Secondary Colors. *This plate and Plate VIII illustrate experiments with orange, green and violet, in the same manner as those made with red, yellow, and blue in Plates V and VI. The conclusions to be drawn from these experiments are fully discussed in Chapter Three. It is of the greatest importance to the student to experiment freely and boldly with all the available colors, and to apply the knowledge thus gained to pictorial compositions. Much time generally wasted on fruitless attempts to paint pictures can be saved by preliminary inquiries into the possibilities or limitations of combinations of a few bright contrasting colors.*

In this demonstration, the secondary colors are superimposed in the following order: (A) orange superimposed over (from left to right) green, orange, and violet; (B) green superimposed over violet, green, and orange; (C) violet superimposed over green, violet, and orange.

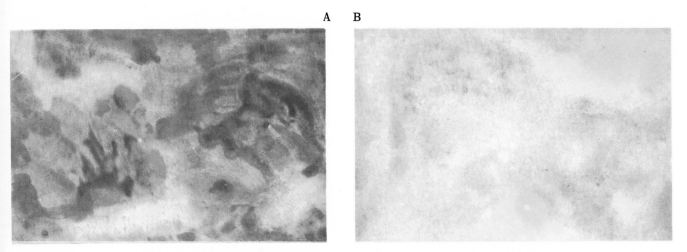

Plate VIII. Mixing the Secondary Colors. *Here, the three secondary colors are combined by mixing. A shows the colors full strength; B shows them after having been diluted with a great deal of water. See Chapter Three for details.*

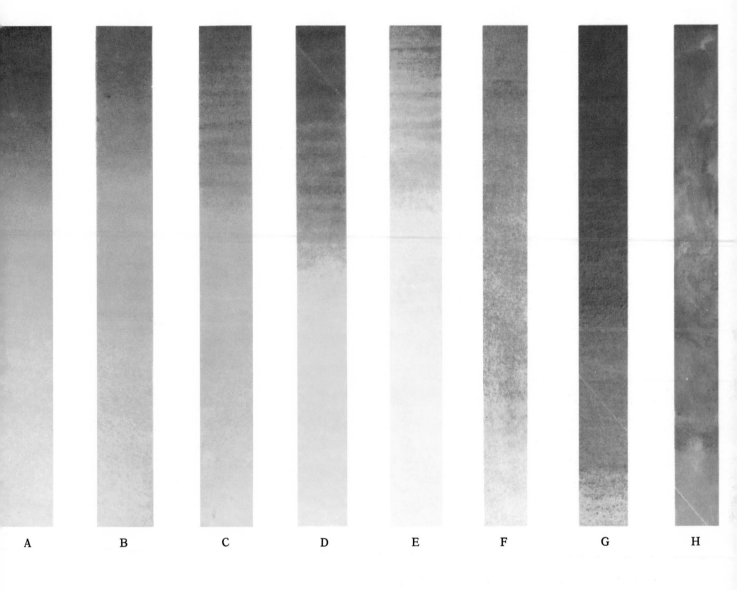

A B C D E F G H

Plate IX. Gradation of Colors. *This plate shows a series of experiments to find the modification of various pure colors when mixed with black and diluted with water. The great importance of the knowledge thus gained is fully discussed in Chapter Three. Few artists realize the extent of the range of color obtainable by using a few bright colors and adding black to each instead of mixing the colors to get modifications. Harmonious and satisfying pictures can be painted by the addition of black to very few bright colors. D alone gives sufficient range for an autumn landscape, and E alone can be made to give an effective rendering of moonlight.*

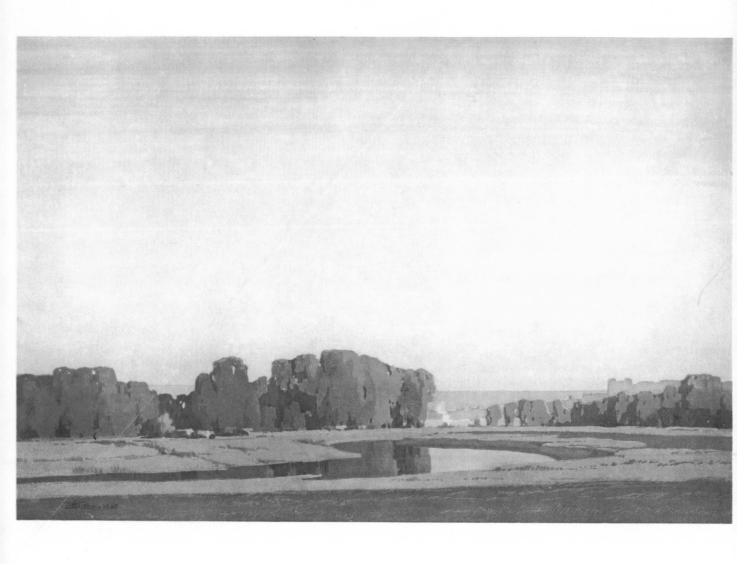

Plate X. A Sussex Valley. *A practical illustration of the value of the information gained by the experiments shown in Plate IX, this picture was painted with a deliberately restricted palette consisting of red, red-orange, orange, yellow-orange, and blue, modified by white, black, and gray. The significance of this restriction is discussed in Chapter Three. This picture was painted with opaque designer's colors, water being freely used as a medium. The effect is much like that obtained by transparent colors. This method enables the artist to paint light and bright colors over dull and dark ones. The lights on the trees, animals, and foreground were painted in this way. The Miller's Cottage (Plate LVIII) was painted by much the same method.*

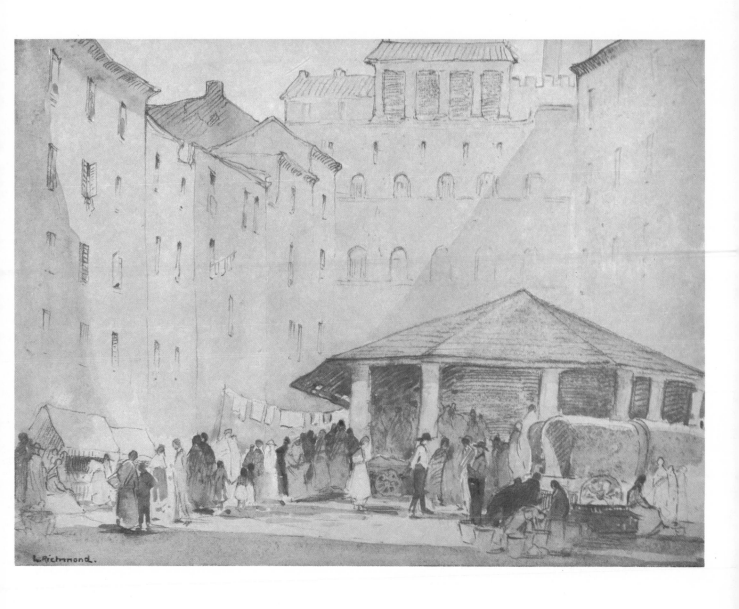

Plate XI. The Market Place, Siena, Italy. *This plate shows an example somewhat in the style of the early school of watercolor art. The pencil brings out salient points that are often missed in a painting of deeper tones; in any case, a tinted painting of this style in conjunction with three or four other color studies of the same subject done outdoors is invaluable when needed for reference in the studio. This watercolor was done on a yellowish-tinted paper with a fairly smooth surface. Full description in Chapter Four.*

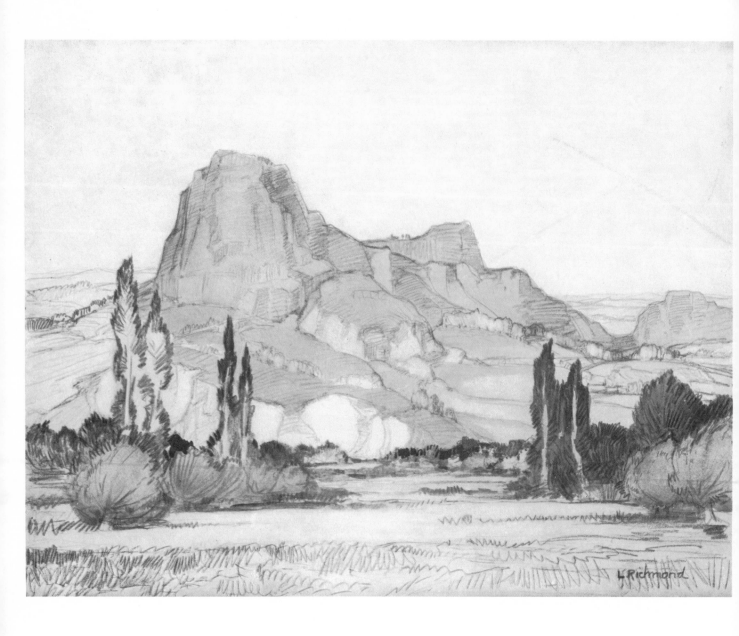

Plate XII. Landscape near Le Puy, France. *Outline pencil studies of this character serve a two-fold purpose. First, the composition or pattern of the subject can be solved when one is sketching outdoors. Second, much detailed information is easily stated without loss of breadth or artistic statement. Like Plate XV, a portion of the picture on the left side is free from color, so that the pencil drawing can be seen in its original state. As regards tones, the pencil outlines convey to a certain extent the desired range. This is clearly seen in the shaded drawing of the dark trees silhouetted against the distant hills. Although very delicate in tint the color washes suggest the correct tonality of the foreground, middle distance, and distance. A detailed description is given in Chapter Four.*

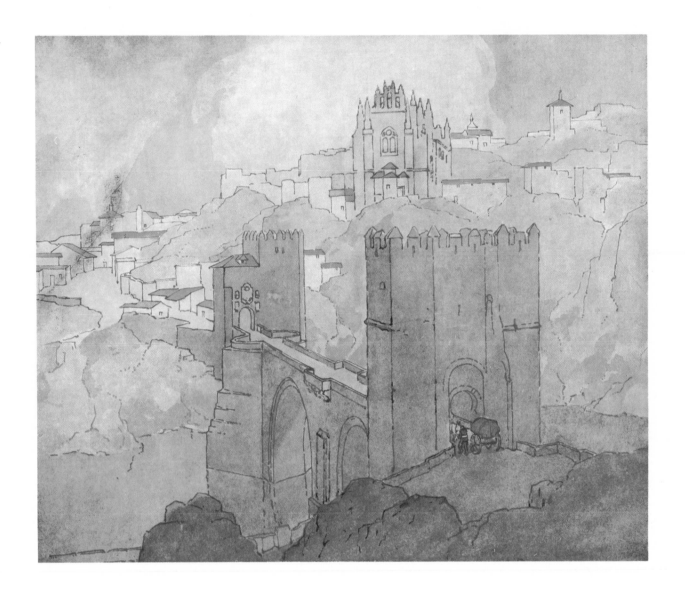

Plate XIII. Toledo *(first stage). This plate illustrates the first stage of an example of a subject demanding exact delineation of many interesting features and details. The distinguishing characteristic of the method is the use of indelible brown ink outlines on a paper with a fairly smooth surface before the painting is begun. The preliminary drawing demands very careful attention, otherwise difficulties will arise when one attempts to complete the subject. It can be done directly with a light lead pencil, or else transferred from a drawing made on a sheet of thin paper. The drawing is then strengthened by using the brown ink, which can also be diluted with water for the more distant scenery. After drying, the whole of the paper is easily cleaned with an eraser preparatory to laying on the necessary light color washes. The method is described in Chapter Four.*

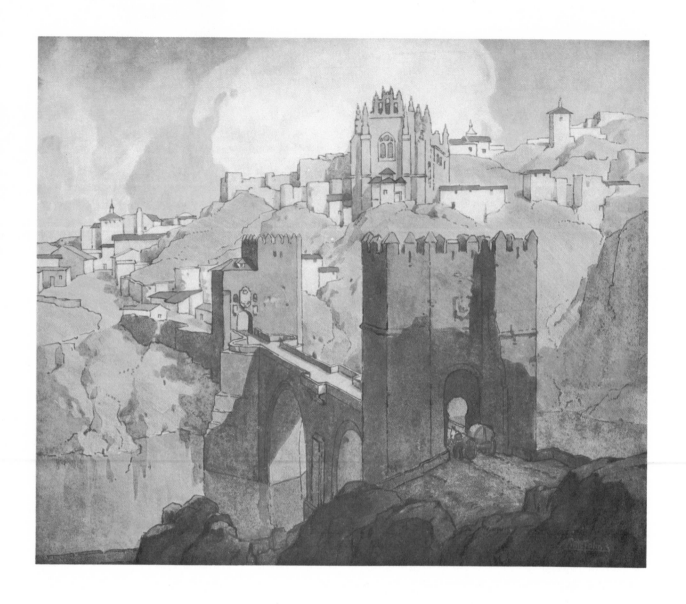

Plate XIV. Toledo *(second stage)*. *In this final stage of the picture illustrating the use of outline and wash, the color tones are more clearly emphasized, particularly in the lower portion of the gateway leading to the bridge and in the rocks in the foreground. A valuable note is struck by the formation of soft clouds contrasting against the rigidity of the distant buildings. Regarded pictorially, this is a complete and expressive method, especially when applied to a subject where topographical detail is predominant. The complete method is described in Chapter Four.*

Plate XVII. Brown Autumn. *This plate illustrates a method somewhat similar to that used in Plate XIV. In this case, the outlines in India ink were drawn after the painting was finished in order to define both structure and details, and to emphasize the rugged character of the scene without losing the broad effect of sunshine and shadow. Considerable contrast is also attained by the adroit use of thin ink outlines as seen in the cloud formations, compared with the massive outlines of the various dark-toned trees. Not only does this style of painting possess artistic interest, but added value is given to the general effect by the intense virility of India ink outlines, which sharpen up the tonality of harmonious color washes. The method is explained in Chapter Five.*

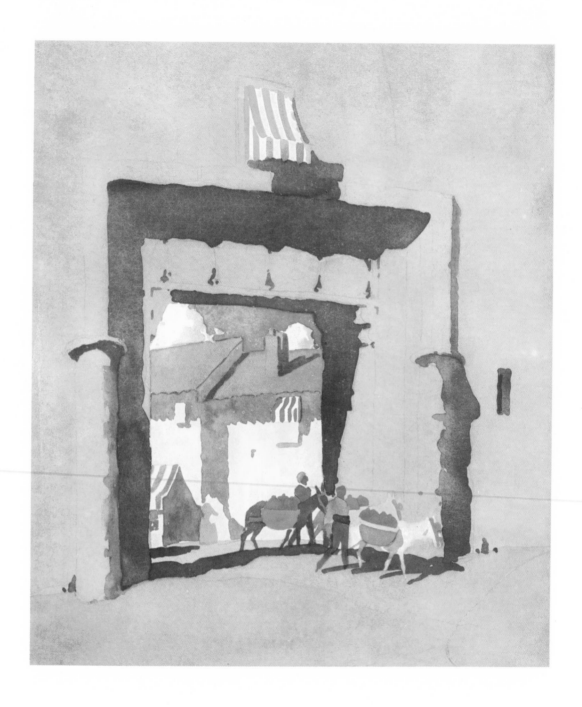

Plate XVIII. A Spanish Gateway *(first stage)*. *This plate illustrates the first stage of a picture painted with flat and slightly graduated washes, in which outlines are disregarded and full reliance is placed upon the wash. A thin, clear outline was made in pencil on a sheet of coarse-grained paper. Yellow ochre and a little light red mixed in a saucer proved sufficient to cover, with a very large brush, the whole surface of the picture except the white donkeys and the portion seen through the doorway. A little rose madder was added to the foreground, cobalt for the sky, rose madder and yellow ochre for the roofs, and pale yellow for the distant walls, etc. Extreme accuracy in drawing and pure color washes are very necessary for a subject of this character. The method is described fully in Chapter Six.*

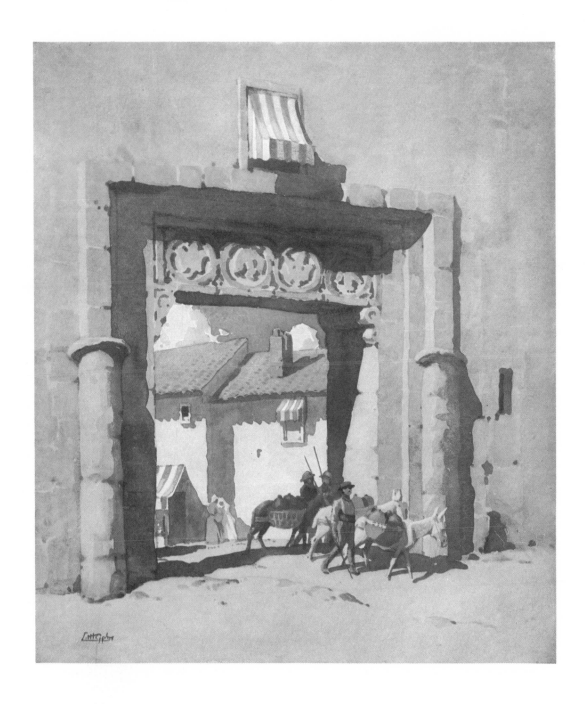

Plate XIX. A Spanish Gateway (second stage). This final stage of the picture commenced in Plate XVIII consists for the most part of intermediate washes, modifying the extreme contrast not only between tone and color but also between the highlights and the deep shadows. Mixtures of reds, blues, and yellows in various proportions, painted in most cases quite crisply, will effect the desired result. This done, there remain only the details of the figures, the dark touches in the carving over the gateway, and a few details which need not be particularized. It will be noticed that a figure has been added to the group. This was not left, deliberately, for treatment in the second stage. It was an afterthought, and its need only became evident after the rest of the painting had been completed. The method is described in Chapter Six.

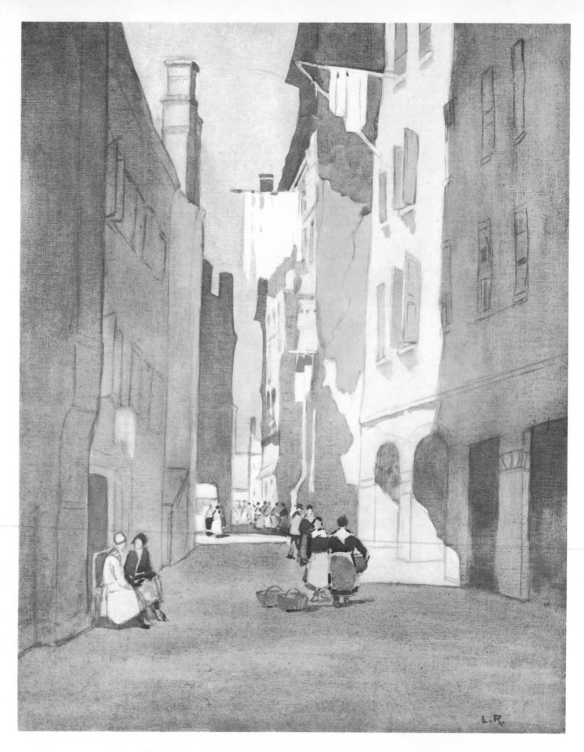

Plate XX. A Street in Chioggia, Italy *(first stage)*. *This is the first stage of a picture painted in pure watercolor washes on white canvas-grained paper. The light clothes hanging vertically downwards represent the actual paper since it is free from any color washes. The purple tints in various parts of the subject were made with a mixture of permanent blue and alizarin crimson. Yellow ochre and a little burnt sienna with plenty of pure water did service for most of the highlights towards the right of the buildings. Any greenish tint in the picture was made with viridian. The figures grouped in the street were intensified in tone to accentuate, through dark tones contrasting against light tones, the effect of sunlight on the buildings, etc., and also, to help the sense of scale, since the small stature of the figures assists in giving a proportional height to the surrounding houses. The bluish-colored wall shadow (immediately above the two centrally-placed women with the baskets) is cerulean blue mixed with purple. Details in Chapter Six.*

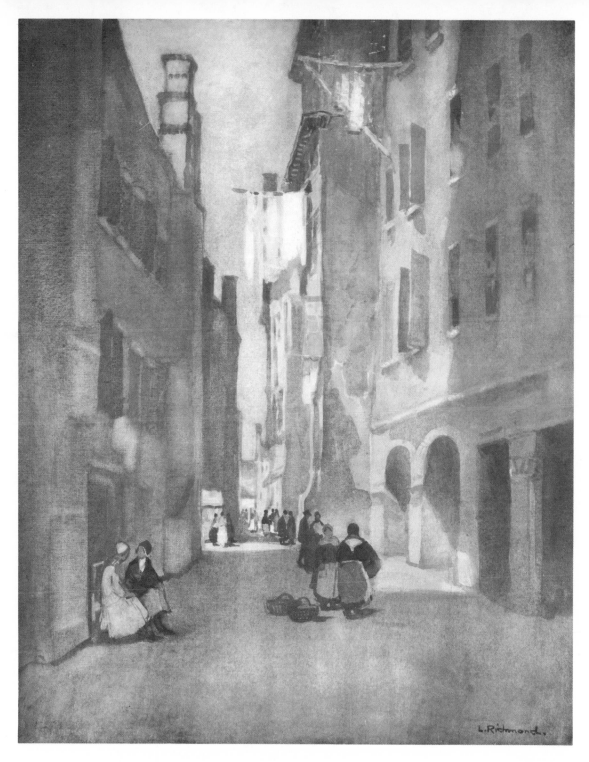

Plate XXI. A Street in Chioggia, Italy *(second stage). This is the final stage of the picture painted on white canvas-grained paper in pure watercolor washes. In most parts of the painting, the colors were painted in with strong tones, so that a small sponge could be used to wipe out with more or less decided effects the patches of halftone and highlights. For some of the highlights, a clean sponge was used three or four times, pressed gently, but firmly, on the tinted paper. For halftones, one application of the sponge was sufficient. In each instance, blotting paper played an important part in absorbing the wet colors immediately after sponging out. To obtain sharp and clear passages of minute highlights, a small bristle oil brush (one that has not been used for oil painting) about ⅛" wide, or a little larger, proved quite adequate for the purpose, with the help of blotting paper. The method is described in Chapter Six.*

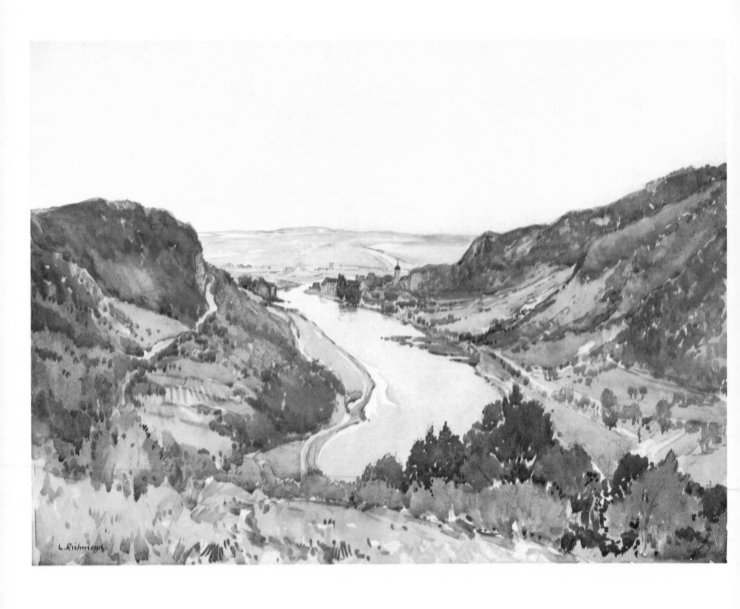

Plate XXII. The River Doubs, near Besançon, France. *In this example of transparent washes on a tinted surface, the tint of the paper is clearly seen in the sky, which was untouched by color so that it could preserve its natural serenity. Considerable time was spent in drawing the subject with an ordinary lead pencil. There is nothing accidental in the drawing and painting. Notice how every house and cottage adjoining the farther bend of the river shows evidences of careful drawing, as well as the minute trees and lines in the far distance. The middle distance from left to right, i.e. the hills with their contours silhouetted against the sky, were originally painted in the same open detailed manner as the spotty effect of adjacent trees, fields, etc., but it is always possible to unite complicated details in a picture by a covering wash of some neutral light color. In this instance the covering wash consisted of bluish gray; this color was then painted in one flat tone over the whole middle distance (with the exception of the intermediate river), thus giving the picture that accented touch which keeps the subject from being dull, without in any way losing the detailed information so necessary in this crowded landscape subject. Full information is given in Chapter Seven.*

Plate XXIII. Wiping Out. *This sketch illustrates the use of wiping out in two ways. It was painted on a very small scale to show the effect of canvas-grained paper. Details in Chapter Eight.*

Plate XXIV. Scratching Out. *This sketch illustrates the combination of the dry method with scratching out and its suitability for certain sky effects. This also was painted on too small a scale for good artistic effect in order that the method might be more clearly shown. A detailed description is given in Chapter Eight.*

1

2

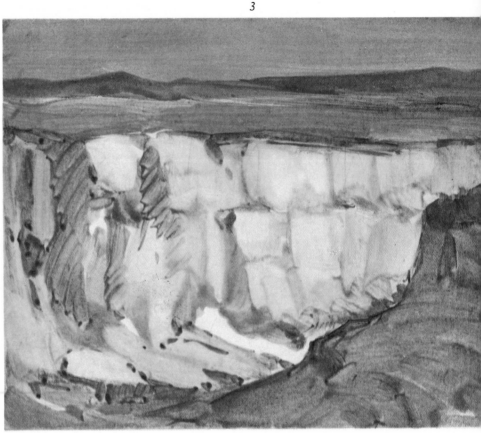

3

Plate XXV. Paste Methods *(demonstration 1)*. *This sketch bears a strong resemblance to the textural surface of oil paint brushmarks. Here, the slightly damp brush was put directly into the paste and then mixed with the purple tint before any painting was done on the drawing paper. The well-defined streakiness or brushmark contours are easily rendered when the color is used with plenty of paste and very little water.*

Plate XXVI. Paste Methods *(demonstration 2)*. *This sketch was painted with a little paste mixed with a generous supply of water. The color, like transparent wash painting, spread with ease on the surface of the paper. To obtain the brushmark in this sketch, the same brush already charged with color was laid flat on the painted surface, and pressed firmly over the ferrule end of the sable hairs, this pressure causing the light spot to appear at the foot of each brushstroke.*

Plate XXVII. Paste Methods *(demonstration 3)*. *This sketch (like the demonstrations in Plates XXV and XXVI) was made on drawing paper and shows some results of the use of flour paste as an adjunct to watercolor painting. No opaque watercolor was used. A most interesting feature in this method of painting, whether on a prepared surface of paste, or with the use of paste directly with the paint, is the way in which the paste holds the watercolor and prevents it from spreading about in an unruly manner. In this respect, there is a certain similarity to oil painting which, when used in a normal style, shows a well-defined brushmark on the surface of the oil pigment. This sketch (as well as the ones in Plates XXV and XXVI) was done while in a wet condition, as regards both paste and color. Details of the method appear in Chapter Nine.*

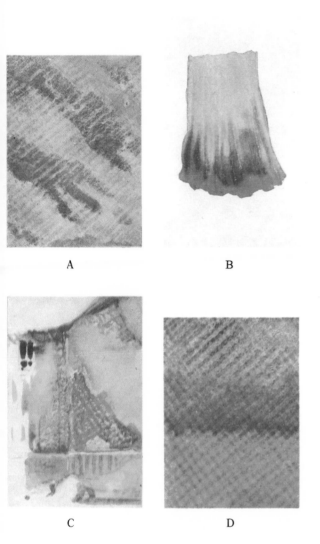

A B

C D

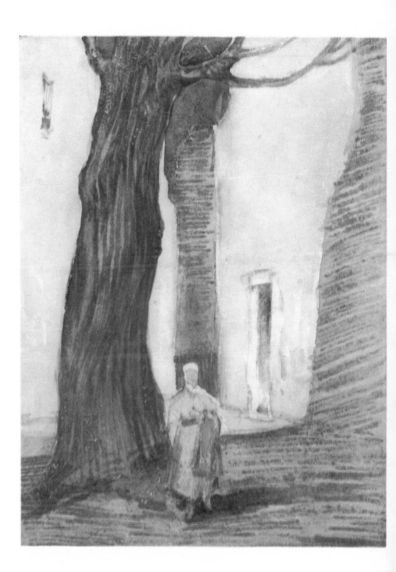

Plate XXVIII. Demonstrations of Scraping Out Process. *These four examples show how various colors look when washed over parallel lines scraped out with a penknife. In A, the lines are scraped diagonally and then painted with similar color washes. B suggests how flowing, scraped curves can be treated with some artistry. The color, when washed over this preparation, runs easily along the grooves caused by the penknife. In fact, it requires little skill on the part of the artist to get an interesting blend of color; although the blending of the colors is to a certain extent accidental, yet it is chiefly controlled by the irritated surface of the paper, which prevents colors from merging entirely into each other and thus destroying the pure wash of the adjoining tints. Flowing curves treated in this manner suggest similar treatment for folds of drapery, curtain hangings, the bark of tree trunks, cornfields, the growth of grass in landscape, etc. In C, the application of scraping is used to convey the impression of old cottage walls showing crumbling surfaces. In D, the lines have been scraped in a crosshatch pattern. See Chapter Ten for details.*

Plate XXIX. Sketch Illustrating Scraping Out Process. *This sketch was made on substantial drawing paper that has been previously scraped with a penknife. The tree trunk in the central picture owes all the bark treatment to the penknife preparation. The method is described in Chapter Ten.*

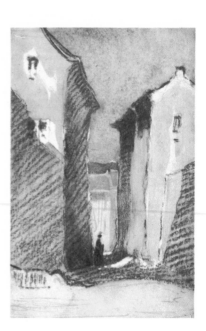

Plate XXX. Charcoal and Watercolor. *Charcoal used in conjunction with watercolor has its own particular characteristic charm. This plate shows several examples of the use of charcoal with watercolor. On the top line, there are two vertical bands of purple: one on the left and the other on the right, both being a pure wash of exactly the same tint. Note how much lighter the first color appears when compared with the corresponding vertical band. The groundwork of the latter was prepared with a thin, soft piece of charcoal stick, applied lightly, and spread evenly on the drawing paper. It was then sprayed with fixative. It is at once apparent that by fixing charcoal in advance, any color that may be applied later is unable to disturb the line drawing, granulated surface, or shadow pattern beneath. The charcoal drawing in the two lower examples was fixed before painting, but the top sketch demonstrates the suggestive qualities of unfixed charcoal, blending more directly with the liquid watercolor washes.*

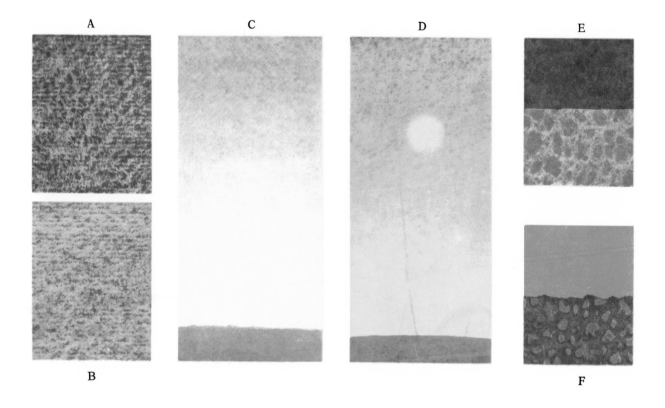

A C D E

B F

Plate XXXI. Use of Tinted Papers—Granulation. *A page of experiments, referred to in Chapter Twelve. A and B show the strikingly contrasted results obtained by using the same colors on the same kind of paper in two different ways. Nos. C and D illustrate the value of toned papers used with transparent watercolors. E and F, painted on very coarse paper for the purposes of clearer explanation, illustrate the different effects produced by the superimposition of certain colors. This branch of watercolor, which is seldom studied or applied, is referred to in detail in Chapter Twelve.*

A B C D E

Plate XXXII. Granulation. *These illustrations are reproduced to the full size of the originals in order to show the remarkable effects of granulation produced by certain colors when used in the manner described in Chapter Twelve. The three narrow strips on the left (A, B, and C) show how a subtly granulated gray effect is produced by three washes. A is pale vermilion, which does not granulate. B shows a wash of cobalt blue, superimposed, and C shows the effect of superimposing a further wash of emerald green. The two wide strips (D and E) show how different forms of granulation can be obtained with the same colors by placing the drawing at a slightly different angle while the wash is drying.*

Plate XXXIII. A Granulated Picture *(first stage). An application to a picture, shown in three stages, of the method shown in Plate XXXII and described in Chapter Twelve. This plate shows the first stage—a coarsely granulated sky, and the ground treated somewhat in the same manner.*

Plate XXXIV. A Granulated Picture *(second stage). This plate shows the method illustrated in Plate XXXII extended to the fountain.*

Plate XXXV. A Granulated Picture *(final stage). This plate completes the picture begun in Plate XXXIII. Some parts have been wiped out and a few dots have been painted to harmonize with the general granular effect. The method is best suited to large pictures. Otherwise the multiplicity of decided spots is apt to be too dazzling.*

Plate XXXVI. Wiping Out from Wet Washes. *An example of the class of subject where wiping out from wet washes can be used for soft effects on canvas-grained paper. This paper has a very hard surface, so that the color remains on the surface and can be wiped off easily, and when the paper is damp the wiped parts dry with soft boundaries. Some pigments settle into the indented parts of the paper and give to the work a pleasant grain. The method is particularly valuable for painting clouds and smoke. The method is explained in Chapter Thirteen and is further illustrated in Plate XL.*

Plate XXXVII. Wiping Out over Inks. *This plate shows an example of wiping out over undertints of indelible inks, and minimizes certain limitations. The method is treated more elaborately in Plate XL, and is explained in Chapter Thirteen.*

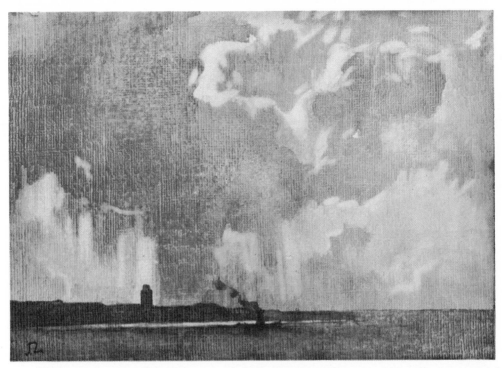

Plate XXXVIII. Wiping Out to Get Sky Effects. *This sketch shows the especial suitability of wiping out to the rendering of dramatic sky effects. Two methods of wiping out are employed: (1) when the paper is wet and, (2) after it has dried. A detailed explanation is given in Chapter Thirteen.*

93

A B C

Plate XXXIX. Reflections in Water. *Three examples showing how indelible inks can be used for painting reflections in water: in A and C the ink was covered with opaque color, and in B with transparent granulating color. Each was painted on paper with a smooth, hard surface, which lends itself readily to wiping out. The method, which is explained in Chapter Thirteen and further illustrated in the two preceding plates, as well as in the following one (The Vermilion Screen), is of special service when spots of various colors need to be left in the same picture. It gives a variety and softness to the edges otherwise unobtainable, and makes effects possible which are generally considered to be outside the range of transparent watercolor.*

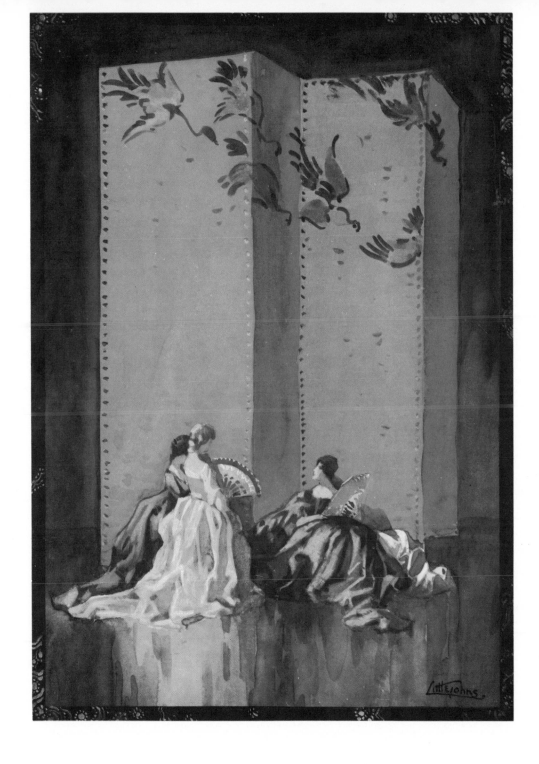

Plate XL. The Vermilion Screen *(preliminary sketch). This is a preliminary sketch for an elaborate picture in which indelible inks play a highly important part, covering most of the surface, and dominating the color scheme. Wiping out is freely employed, and the partial opacity of certain colors classed as transparent is exploited. The method is fully explained in Chapter Thirteen and further illustrated in Plates XXXVI, XXXVII, XXXVIII, and XXXIX. This illustration offers a suggestion for the treatment of fanciful subjects of a decorative character, where the effect is produced largely by means of a few touches of light and bright colors standing out from surrounding dark and contrasting ones. It thus becomes a substitute for opaque color.*

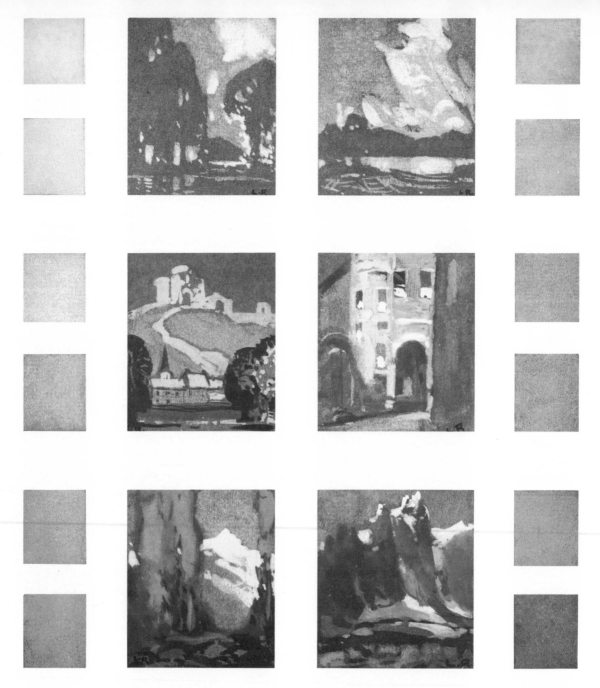

Plate XLI. Series of Twelve Graduated Color Demonstrations and Six Pictorial Sketches. *All the landscape sketches and the vertically placed gradated color demonstrations in this plate were painted on the same cool brown paper, the color of which is clearly noticeable in the flat surface of the tall trees as seen in the small landscape on the top left, and the horizontal range of hills in the landscape on the top right. Referring to the series of twelve small demonstrations of gradated color effects, the top left demonstration is a mixture of opaque white and a little yellow ochre. The three colors immediately below show the result of adding more water to each demonstration. Notice how the repeated addition of water weakens the original light color at the top, thus causing the dark-tinted paper underneath to become more and more apparent to the eye, so that the fourth, or last, demonstration in each series is the nearest approach to the actual color of the paper. The other two gradated color effects, rose-purple and orange chrome, were treated in the same manner as the cream-tinted demonstration. The six pictorial sketches are based on the adjoining color demonstrations, and on the theory stated in Chapter Fourteen. The two top landscapes should be mastered first, as they represent the foundation on which to build. Details in Chapter Fourteen.*

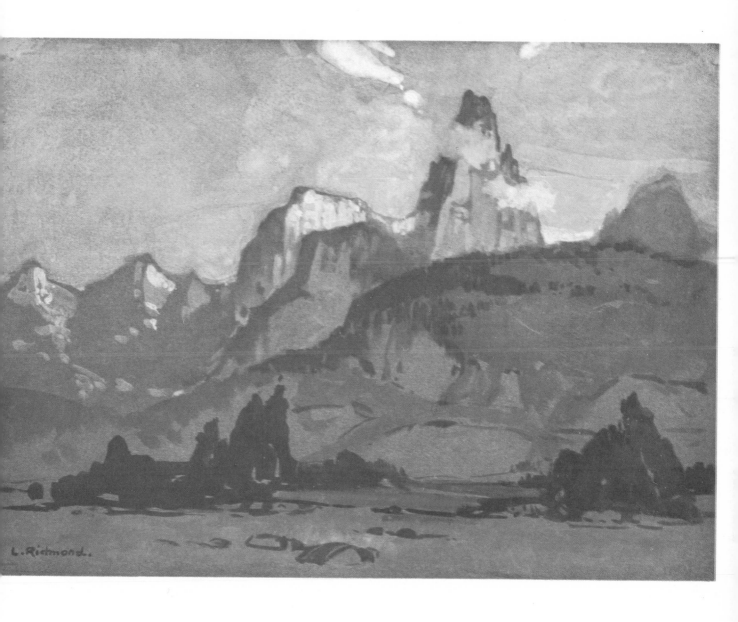

Plate XLII. A Mountain Sketch on Brown Paper in Four Colors. *This plate represents a mountain subject painted on cool brown paper in four colors only: ivory black, permanent blue, viridian, and yellow ochre mixed with opaque white. The student who has made enough copies of the examples on the previous plate so that mastery has been attained will have no difficulty in attempting a subject on a much larger scale. After a slight charcoal outline on the brown paper has been completed, the sky must be painted first, as the silhouette caused by the mountain heights is of more importance than any other portion of the landscape. The next item is the dark foreground trees, for which plenty of ivory black is used. They have the value of sending the general mass tones of the distant mountains into their correct position—well behind the foreground trees. The method is described in Chapter Fourteen.*

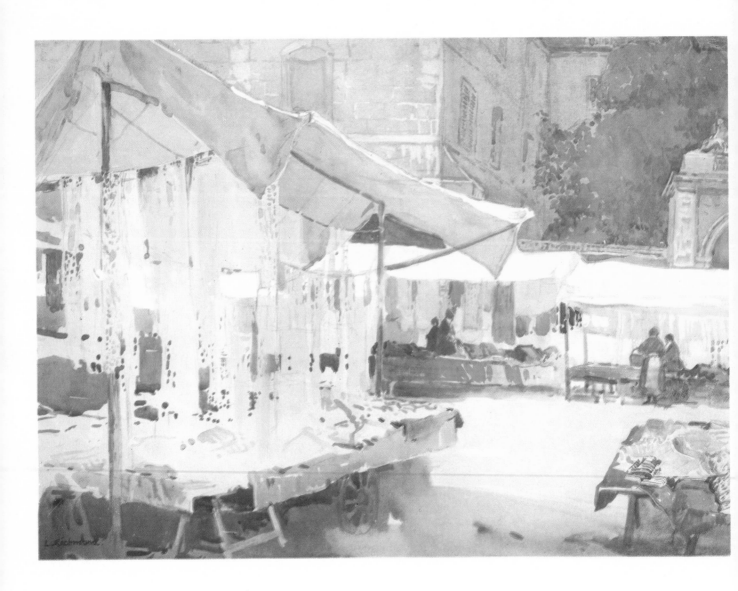

Plate XLIII. The Lace Market, Besançon, France. *The paper used for this picture was appropriate for the subject, i.e. a greenish gray, the original color of which can be seen in the larger window immediately above the awning of the lace stall. Before any detail was attempted in the vertical bands of hanging lace and materials below, the various silver gray tones were painted with very little opaque watercolor and plenty of water. Thicker opaque watercolor was used for the top of the various tents or awnings centrally spanned right across the picture. A subject of this description demands thought before painting. It is not a difficult matter to lay in a false tone which would destroy the harmony of the whole picture, since most of the colors are so delicate in tint, that even a slight exaggeration of any one color would assert its presence, and thus destroy the correct tonality of the other colors.*

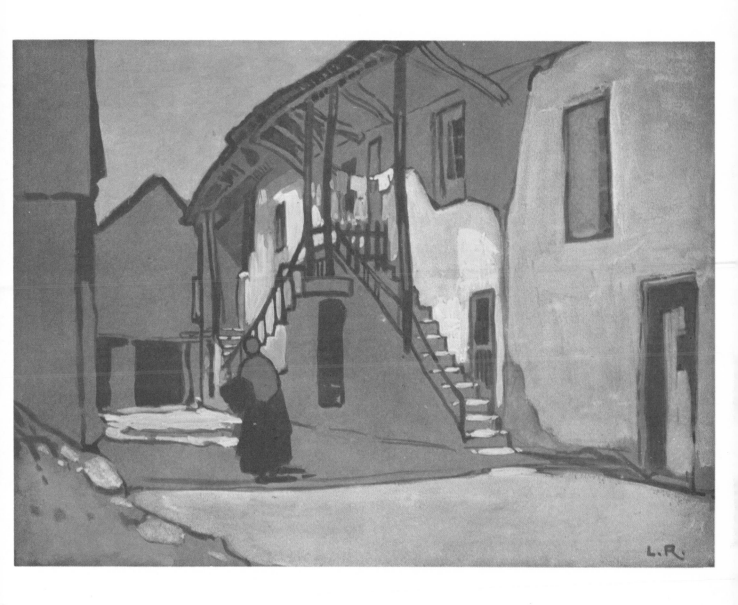

Plate XLIV. Cottages of Beure, near Besançon, France *(first stage). The color of the paper on which this subject is painted is dark gray. It is very noticeable on the left side, since the color washes were not allowed to molest the shadow section of the picture. It is a delightful paper for opaque watercolor painting. Its cool tone gives the illusion of transparent shadows, especially when the gray is contrasted against the warm highlights. Remembering the method involved in the gradated exercises in tone from one color only in Plate XLI, the student should now be able to tackle the simple handling required for the first stage. The sky, being dark, was painted in first, although little color was needed as the paper is also dark. The colors used for the halftone lights are yellow ochre and burnt sienna mixed, of course, with opaque white, well diluted with plenty of water. A little purple, crimson, and green are the other three colors that were found necessary to complete this plate. Notice how the untouched gray paper assumes luminous qualities after the halftone lights and the purple-gray sky have been painted in.*

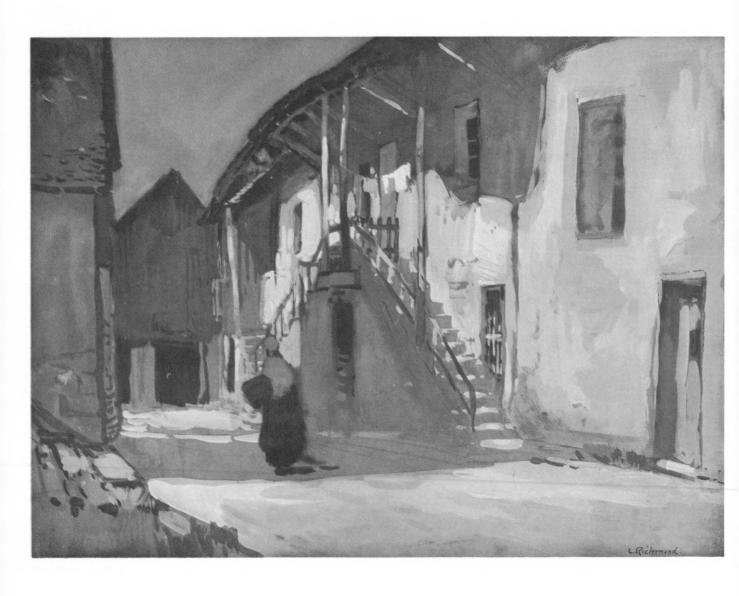

Plate XLV. Cottages of Beure, near Besançon, France *(second stage). This is the final stage of the previous plate illustrating the use of medium thickness of opaque watercolor. The shadow colors consist of a little ivory black, burnt sienna, and violet. In finishing dark shadows the very smallest particle of opaque white should be used, as pure liquid color washes not only deepen the tone of the paper, but also help to retain the luminous atmosphere peculiar to shadows. Yellow ochre— and in places burnt sienna—were mixed with white for painting in the highlights, while the ground color was still wet.*

Plate XLVI. A Pas-de-Calais Scene *(first stage). The principles relating to the application of gradated opaque watercolor washes described and illustrated in Chapter Fourteen should prove a good foundation for this first stage of this landscape subject. The color of the paper is a light, warm yellow, which can be seen in the cloudlet at the top of the picture. A description is given in Chapter Fourteen.*

Plate XLVII. A Pas-de-Calais Scene *(second stage). In this final stage, the sky was dealt with first, being painted with solid opaque watercolor. The hills and trees in the farther distance were painted over the lower part of the sky while still wet. The various tones from the distant hills down to the nearer foreground were deepened, and detail was added in the trees, etc. Much care had to be exercised in retaining the purity of the thick color pigment by using clean brushes and working with rapidity. It is merely a matter of additional time in suggesting more detailed forms in a landscape of this type of scenery, but the artist preferred to insist more on the general decorative pattern of a decorative subject.*

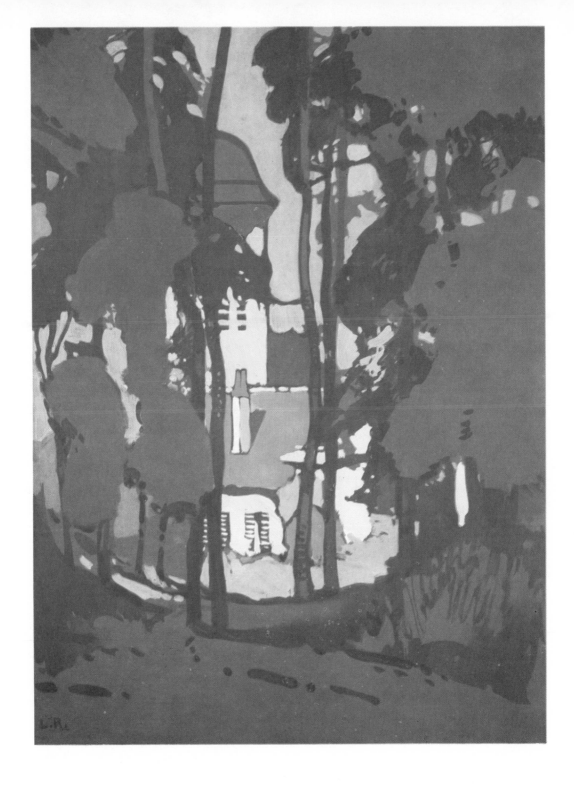

Plate XLVIII. A Glimpse of Besançon Cathedral, France *(first stage)*. *The paper on which this subject is painted is dark brown, but not cool in tint like the examples on Plate XLI, thus requiring more drastic treatment from a color standpoint. The preliminary outlines and shadow massing in the trees and foreground were done with indelible India ink mixed with Vandyke brown. The purple-gray sky was then painted behind the trees, also the various warm, light colors, as well as deep blue and purple shadows spaced about the cathedral. It is very interesting to observe the growth formation of the tall trees caused by the contrast of light versus dark. The color pigment was painted very solidly for the bright highlights.*

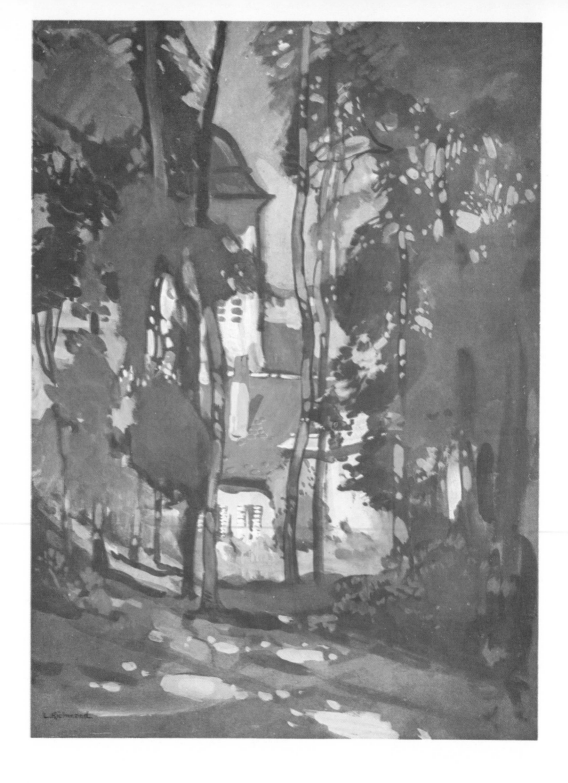

Plate XLIX. A Glimpse of Besançon Cathedral, France *(second stage)*. *To achieve success in this final stage, a very large mixture of opaque white must be used in the highlights of the painting—especially on dark paper. This, however, will bring about disaster unless the painting is done with quick, decisive touches. The paint-brush must be fully charged, so that the paint (despite its thick consistency) is almost falling off the brush before being applied to the paper. In this example, more detail was suggested in the contours of the trees and the painting of touches of lights on the trunks and branches in addition to the lights flickering across the foreground at the foot of the picture. The method is described in Chapter Fourteen.*

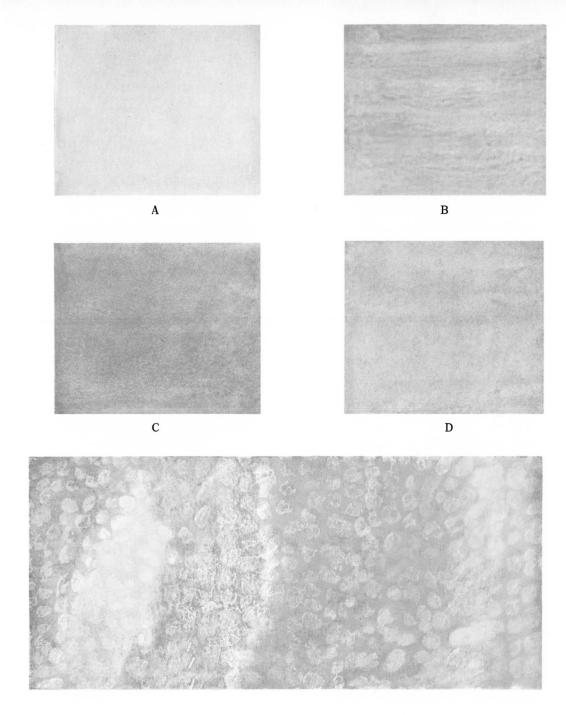

A

B

C

D

Plate L. Illustrating Experiments in Manipulating Different Tones in Opaque Watercolor on Drawing Paper. *The top left demonstration (A) gives the brilliancy of color that results from using a flat wash of liquid transparent lemon yellow on the top of a flat coat of opaque white (the white paint was allowed to dry completely before the lemon yellow wash was laid on). A square sable brush, about ¾" wide, was used for all these opaque watercolor experiments so as to allow the ordinary color washes to be quickly and lightly painted, and leave the color underneath undisturbed. B illustrates the charming effect which can be obtained by laying a liquid wash of light violet tint over a groundwork of lemon yellow opaque color. The middle left diagram (C) is just a pure wash of burnt sienna, and the middle right diagram (D) illustrates the result of a thin coat of opaque white painted rapidly over the burnt sienna tint. Notice how the warm tone of the burnt sienna changes under the influence of a little white, diluted with plenty of water. See Chapter Fifteen for details.*

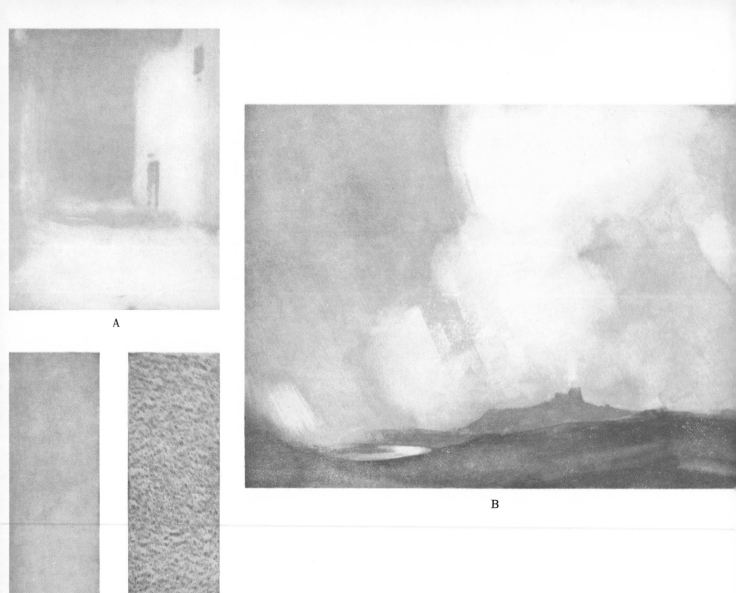

A

B

C

D

Plate LI. Experiments with Wash and Opaque Watercolor, and Demonstration Sketches. *In the two sketches (A and B) a flat ground wash of opaque watercolor, which was carefully mixed and prepared before painting, was laid with a large brush on the white paper. While this color was quite wet, a good-sized damp sponge was used rapidly for sponging out the lighter portions of the sketch. No time was lost between the flat painting and the sponging out. The sponge should be cleansed in clean water after each patch of opaque color is wiped off the surface, unless there is any special reason for not doing so, such as an attempt to secure a halftone tint ranging between the highest light of the drawing paper and the depth of the opaque color, but at first it is as well not to try this. If the color is allowed to dry before the sponge is used, it becomes exceedingly difficult to control the medium, and the contours of buildings, etc., assume a harder and sometimes a lacerated edging, instead of the softer artistic surface as appears in the illustration. The two panels (C and D) illustrate the fact that any tint of opaque watercolor painted with solid consistency results in an opaque surface, whereas nearly every watercolor, if washed with a generous amount of water, creates the illusion of transparency. Panel C is pure watercolor wash; panel D is approximately the same color, in with opaque watercolors. Details in Chapter Fifteen.*

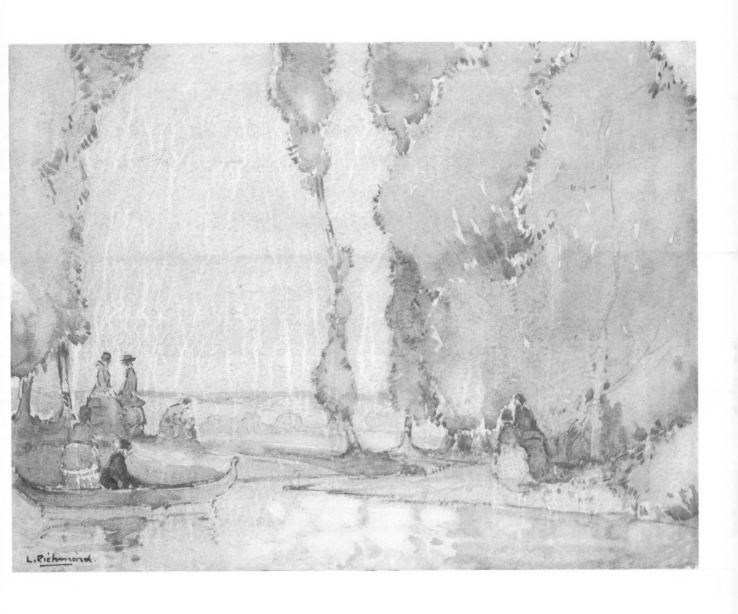

Plate LII. The River. *An example of landscape painting in which use has been made of washing transparent colors over a thin coat of opaque watercolor, and of sponging out. The subject, in its initial state, was drawn carefully in lead pencil, with a fairly black line. Then a warm gray was mixed, to which was added a large quantity of water. The drawing paper having been placed in an upright position on an easel, a large brush was dipped into clean water and then applied to the thinly-mixed opaque watercolor. The opaque color was painted horizontally across the paper rather rapidly, until the whole picture ground was covered, including, of course, the pencil drawing. The semi-thickness of the tint used made a vertically-inclined streak to appear in the painting (caused by the upright position of the paper), which has a certain agreeable quality of textural value. The paint was not thick enough to disguise the drawing beneath.*

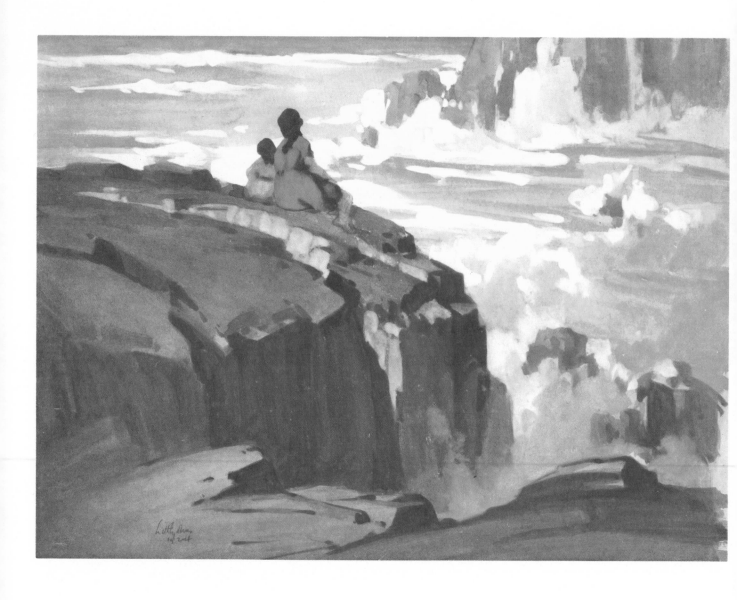

Plate LIII. The Watchers on the Cliff. *A picture painted in opaque watercolor on soaked paper—an attractive but little-used method for combining transparent color and Chinese white and completing the picture in one operation. As the paper is in constantly changing states of dampness while the painting is in progress, every degree of softness and hardness is possible. The method is especially suited to the expression of movement and of misty effects, and is further described in Chapter Sixteen.*

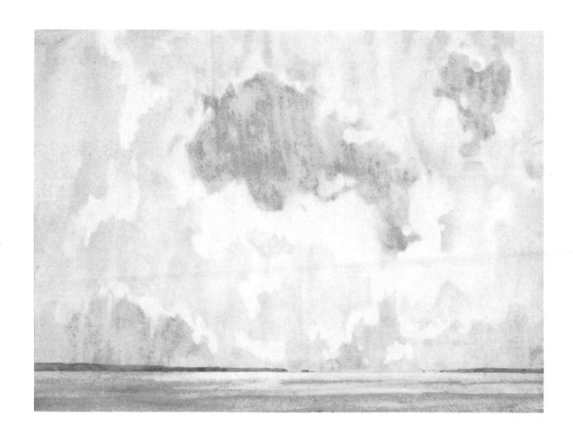

Plate LIV. A Windy Sky. *This plate and Plate LV illustrate a new method of using dry pigments instead of watercolors. Though fragile and needing as careful preservation as pastels, the results are unique. The method is limited and therefore can be applied only to appropriate subjects. But by the addition of indelible inks, in the manner described in Chapter Thirteen, the value of the method can be considerably increased. A fuller description is given in Chapter Seventeen.*

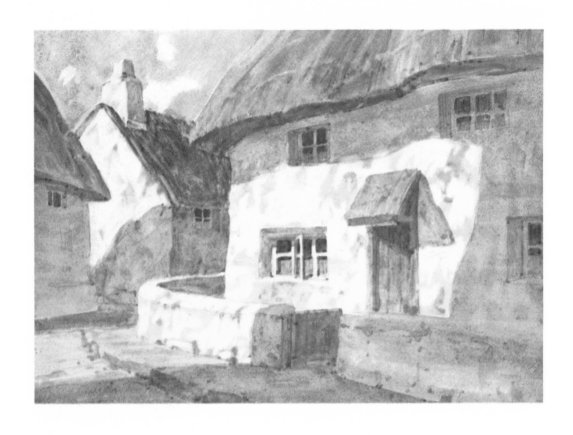

Plate LV. In a Devonshire Village. *The passages of light on the shaded white walls further illustrate the method of using dry pigments instead of watercolors. Details in Chapter Seventeen.*

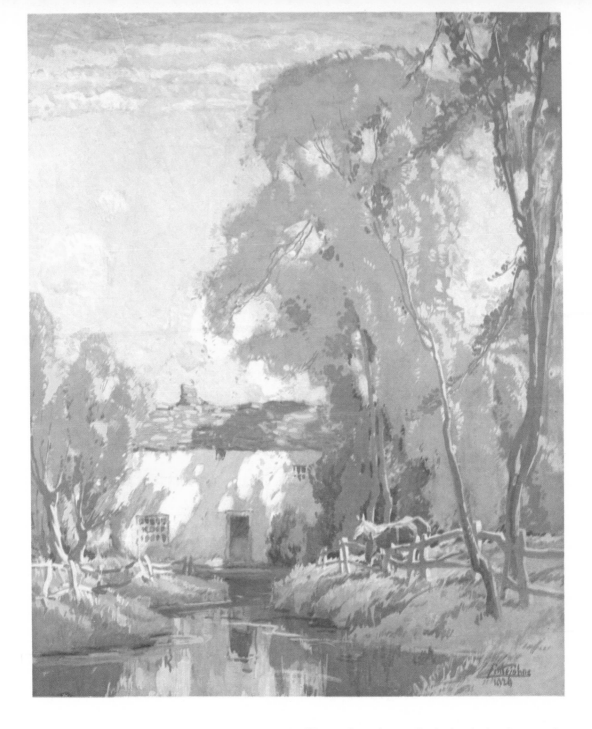

Plate LVI. The Miller's Cottage. *An illustration of a method of painting in gouache suggested by a pastel, in order to obtain a combination of delicacy and brilliance. In the pastel, all the undertones were rubbed in with the finger so that the details could be indicated in clear strokes, in order to obtain a combination of delicately modulated color in the masses with the utmost decision in the lighting. This kind of effect can be obtained more completely by painting with opaque colors instead of pastel. In this example, the undertones were painted thinly over gray paper. Several layers were necessary until the exact color, tone, and softness were obtained. Then, when quite dry, the touches were painted with sufficiently stiff color to be uninfluenced by the parts below. As most of the colors are considerably lighter when dry, each was tested on a separate piece of paper before being used. These two methods, like some others dealt with in previous plates, have never been sufficiently investigated. The writers hope that the suggestions they have given will stimulate further inquiry. The possibilities of fresh and desirable effects are endless.*

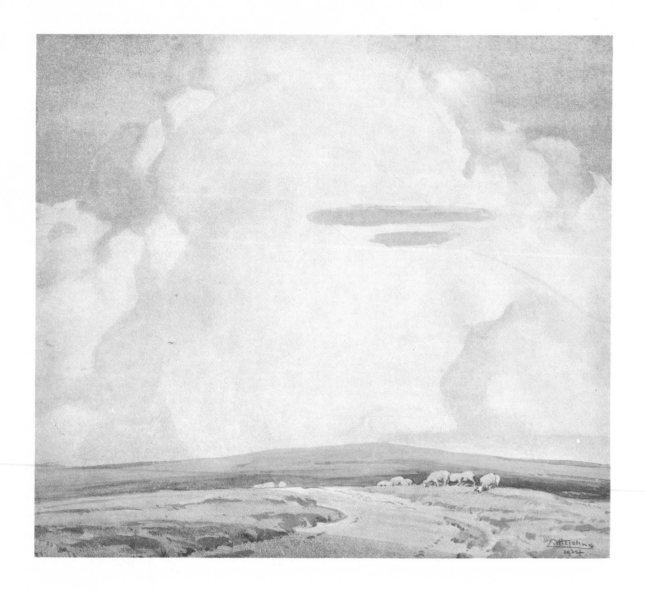

Plate LVII. The White Cloud. *A lucky accident with a moral. This picture would have been destroyed as a failure but for a series of experiments with unexpected results. The circumstances are recorded in Chapter Eighteen. It is a mistake to immediately destroy every failure. Sometimes, when examined later, they are found to contain valuable suggestions; or, by methods of treatment which the student has mastered in the interval, they can be retrieved. Large masses of trees may cover blunders in the painting or composition of a sky; strong shadows in the foreground may give the remainder the required delicacy; figures, animals, buildings may add the necessary interest. Destroy nothing until, after calm deliberation, you are sure that it can be of no service.*

chapter thirteen

WIPING OUT

ONE OF THE GREATEST technical difficulties, when one is using any of the foregoing methods, is to leave small passages of lights of the exact shape and clearness required. Indeed, many subjects would have to be avoided altogether but for some methods of removing part or all of the color from certain portions of the picture after the paint has been laid on. The most common method is that generally known as *wiping out*. A few simple experiments will serve to show the extent to which it can be effected satisfactorily, and the class of subject to which it can be reasonably applied.

Experiment with Papers and Colors

Take two small pieces of paper—one hot pressed, and the other cold pressed. Lay a strong wash of cobalt blue on each and dry thoroughly. Then lay each piece flat on the table and cover a space, say, as big as a half dollar piece, with as much water as it will hold without overflowing. At the end of a minute, dry with blotting paper, using considerable pressure. Most of the color will come away from the smooth, hard surface of the hot pressed, but very little from the uneven and comparatively soft surface of the cold pressed paper. Fill the spaces with water again and rub them with a stiff, clean bristle brush. When blotted, the hot pressed will be quite clean, but the cold pressed will still be slightly stained. Try the same experiment on a very porous paper and comparatively little color will come away.

Repeat the experiments with each color in the box and keep them for reference until you can remember the results.

From these experiments, there emerge two facts so important as to almost dominate the painting of a picture where wiping out is a prominent feature, viz. the necessity for a paper with a smooth, hard surface, and the restriction of the palette to those colors that can be wiped out, to the extent required, on the paper chosen.

Choosing Paper

The choice of paper is complicated by the fact that most smooth papers are exceedingly difficult to handle, as a superimposed wash is apt to disturb the one beneath. One paper, however, a drawing paper stamped to look like canvas, and having an almost burnished surface, takes superimposed washes if they are laid on lightly, and is particularly amenable to wiping out. This paper was used for the illustrations in Plates XXIII, XXIV, XXXVI, XXXVII, and XXXVIII. As it is rather thin, it should be stretched or mounted, preferably the former.

How to Prepare Paper for Wiping Out

Almost any paper can be made amenable to wiping out by the adoption of a very simple expedient. Mix a strong wash of some color that does not wipe out easily. Add to it a little glycerin and apply the mixture to what is, in other circumstances, an unsatisfactory paper for the purpose. The relative quantity of glycerin can be arrived at only after several trials. When the proportion has been found, the color, instead of sinking into the paper, will float in a bath of glycerin and water for a considerable time on account of the slow-drying nature of the glycerin. During this time, the color will come away from almost all papers with the slightest touch of the brush; and when the wash is quite dry, the color can be removed from any paper with a fairly hard, smooth surface.

Preliminary Ink Washes

Paradoxical as it may seem, the very suitability of the paper to the process creates artistic limitations, because the more amenable the paper, the more nearly white the wiped out light; consequently, the range of subjects tends to be restricted to those effects where white lights only are needed.

This difficulty can be met to a considerable degree by a method which has hitherto received very little attention—the painting of preliminary washes of indelible inks, diluted as required. Plate XXXVII is a simple example of how indelible ink might play a distinctly important part and produce effects impossible to obtain in any other way. The picture first received a wash of ink over the sky, varying from the pink on the left to red on the right, producing pink clouds on the left and showing through the blue paint on the right sufficiently to give a suggestion of purple. The rest of the paper was stained with a flat wash of yellow ink. The whole of the trees were then covered with a wash of brown and the yellow trees were wiped out with a very small, stiff-haired bristle brush.

This method, with all its possibilities of extension, has its limitations also, in so far as the inks influence the color of the superimposed washes. A dark color painted on a pale ink might scarcely be affected by the influence of a strong ink showing through a pale transparent wash. Example B, in Plate XXXVIII illustrates this point where, in spite of the blue-purple washes, the orange ink dominates the whole color scheme. Such effects as those shown in A and C on the same plate necessitate the use of strong opaque watercolor to

obliterate the streaks of red, green, and orange inks. But, used with discretion and forethought in conjunction with a suitable subject, the method gives ample opportunities for exceptional and powerful effects.

Wiping Out with Cheese Cloth

Wiping out is generally done with a clean, damp brush, and in many circumstances there is no other way. But few artists are acquainted with the almost magical properties of cheese cloth. A few exercises will indicate its value and point to many further uses: Lay a much gradated wash of cobalt blue on a rather smooth paper, and, without preliminary drawing or thought, dab with a small, loose wad of cheese cloth to produce white clouds. First dab very slightly; then more heavily on the lighter parts of the clouds, varying the pressure as required. The accidental effects will be certain to give unexpected and delightful suggestions. Now, in a second experiment, lay a wash of the same color with a strong admixture of glycerin. Note the softness of the edges when the wash is very wet and the increasing definition when the wash begins to dry. If a large wash persists in remaining uneven try to restore it with a large, loose wad of cheese cloth. All sorts of interesting things may happen!

AT HOME by Walter Biggs.

Here is a lively use of opaque and transparent watercolor, combined to yield varying degrees of transparency, semi-opacity, and opacity. The light notes in the extreme foreground tend to be dashes of quite opaque color, which melt away into the semi-opaque and transparent dark beyond. The painting gives the effect of a profusion of detail, but on careful study, it becomes clear that everything is done by the merest suggestion. Almost the entire picture consists of blurs of color which flicker and merge into one another, magically congealing into a landscape. However, the artist has reserved precise strokes for a branch or twig here or there, the fence, and a few blooms in the foreground. These crisp strokes are far from precise, but they have a delightful, rambling quality, giving the entire picture a feeling of casual spontaneity. (Photograph courtesy American Artist.)

chapter
fourteen

OPAQUE WATERCOLOR

Opaque watercolor (transparent color mixed with Chinese white or gouache white) is capable of expressing a very wide range between strength and delicacy, light and shadow, bright colors and dull colors. A larger variety of tone can be achieved than is generally realized by the beginner.

It is excellent practice to paint on dark paper and try to get as many different tints as possible by starting from any given light color, gradually coming down the scale of tones from light to dark, by adding fresh water to the original color after each painting. The darker the paper, the more simple it becomes to demonstrate a larger number of color tones.

Thin Opaque Watercolor

The landscape sketches and the vertically placed gradated color demonstrations in Plate XLI were all painted on the same cool brown paper, the color of which is clearly noticeable in the flat surface of the tall trees as seen in the small landscape on the left, and the horizontal range of hills in the landscape on the right; both sketches are placed on the top line.

Any light color that is chosen for the purpose of practicing should be made from nearly all white pigment, mixed with a very small proportion of some definite color. Gouache white was used in all the colored plates in this chapter.

It is surprising how quickly the technique of opaque watercolor painting can be learnt, and the far-reaching effect of tones discovered with simple but intelligent practice. For example, look at Plate XLI, which shows, apart from six pictorial sketches, a series of twelve small demonstrations of gradated color effects. The top demonstration, commencing on the left side, is a mixture of white and a little yellow ochre. The three colors immediately below show the result of adding more water to each demonstration. Notice how the repeated treatment with water weakens the original light color at the top,

thus causing the dark tinted paper underneath to become more and more apparent to the eye, so that the fourth, or last demonstration in each series, is the nearest approach to the actual color of the paper.

The four rose-purple tints on the right hand side were treated in precisely the same manner as the other examples, water being added to each demonstration immediately below so as to darken the tone of the original rose-purple at the top of the series. The color was made with a mixture of alizarin crimson, permanent blue, and white. All the watercolors mentioned in this chapter were used from tubes, including the gouache white.

The last four-color demonstrations, two on each side of the plate, are derived from orange chrome only. Here again, the three gradated tones arising from the original orange chrome most eloquently prove the thinning value of mixing water with opaque watercolor.

The six pictorial sketches are based partly on the adjoining color demonstrations, and entirely on the theory already stated in this chapter. The two higher landscapes should be mastered first as they represent the foundation on which more complicated designs can be built. There is only one color used: yellow ochre mixed with white. The four adjoining demonstrations on the left suggest the tones used for painting the landscapes. The true value of the dark clouds is about the same depth as the fourth, or last, gray color, and that of the light clouds is about equal in value to the first and second color demonstrations. The colors for the buildings in the middle landscape on the right are derived from the same source, with the addition of ivory black mixed with a little burnt sienna and a touch of white for the deeper shadows.

The sky in the middle landscape on the left was made of the thinnest possible wash of permanent blue, and orange chrome mixed with white for the castle ruins, winding pathway, etc. The ground on each side of the winding path is the same gray as the fourth demonstration from the top. Ivory black was used to help the tone of the foreground trees.

Obviously, orange chrome can be seen in the three tall trees in the lower sketch on the left, while the color of the sky is derived from the fourth purple demonstration, counting from the lightest tint above. Alizarin crimson, burnt sienna, and black were invaluable for the foreground, with white mixed with a little yellow ochre for the snow-capped mountain. Permanent blue, alizarin crimson, black, and purple-gray composed the color scheme for the lower sketch on the right.

Plate XLII represents a mountain subject painted in four colors only: ivory black, permanent blue, viridian, and yellow ochre mixed with white. The student who has copied the examples on the previous plate until mastery has been attained will have no difficulty in attempting a subject on a much larger scale. After a slight charcoal outline has been completed on the brown paper, the sky must be painted first, as the silhouette caused by the mountain heights is of more importance than any other portion of the landscape.

The next item consists of the dark foreground trees, for which plenty of ivory black is used. This feature sends the general mass tones of the distant mountains into their correct position—well behind the foreground trees. The suggestion of dark tree growth centrally placed in the nearer mountainous forms was done with permanent blue. The green (viridian) is very thinly washed over certain portions of the landscape so that the brown paper is

able to neutralize the vivid effect of green. The actual color of the paper can be seen mostly in the foreground.

The painting *The Lace Market, Besançon, France* (Plate XLIII), done outdoors, was very difficult to manage. The paper used was appropriate for the subject, i.e. a greenish gray, the original color of which can be seen in the larger window immediately above the awning of the lace stall. In the treatment of the buildings behind the lace stalls, care was taken by the artist in drawing the upright contours of the walls, windows, etc., not to adhere too rigidly to straight lines, so as to convey the necessary feeling of antiquity. Thicker opaque watercolor was used on the top of the various tents or awnings centrally spanned right across the picture. Before any detail was attempted in the vertical bands of hanging lace and materials below, the various silver gray tones were painted with very little opaque color and plenty of water. When the paper was dry, a small paintbrush was used to show the detailed portions of the lace, etc.

A subject of this description demands thought before painting. It is not a difficult matter to lay in a false tone which would destroy the harmony of the whole picture, since most of the colors are so delicate in tint that even a slight exaggeration of any one color would assert its presence, and thus destroy the correct tonality of the other colors.

Medium Opaque Watercolor

The color of the paper, being dark gray, is very noticeable towards the left side of the first stage of *Cottages of Beure, near Besançon, France* (Plate XLIV), where the color washes were not allowed to molest the shadow section of the picture. It is a delightful paper for opaque watercolor painting. Its cool tone gives the illusion of transparent shadows, especially when the gray is contrasted against the warm highlights.

It is as well to remember that only papers with a matt or dull surface should be used for opaque watercolor painting, so that the paint can be absorbed to a certain extent into the paper. A shiny or hard surface is not only extremely unpleasant to work on, but the thicker method of opaque watercolor painting is not so liable to adhere to the surface.

A soft black lead pencil was used to indicate the general proportions of the first stage, but owing to the dark tone of the paper, it was found advisable to make a mixture of two waterproof inks—India and Vandyke brown—so as to get a definite outline in addition to a few solid masses such as the skirt of the figure with the basket and the doorways. It is better for two reasons to err on the side of heavy lines and thick massing in the preliminary color outline than to have an artistic rendering of thin lines. First, the strong line which indicates not only the contours of buildings, but also the boundary lines of shadows, gives an excellent foundation for laying on color washes (see reproduction). Second, however thick a dark color line may be, it can easily be disguised (or, if necessary, completely hidden) by the solidity or opacity of the final painting.

Remembering the method involved in the gradated exercises in tone from one color only in Plate XLI, the student should now be able to tackle the simple handling required for the first stage. The sky, being dark, was painted

in first, although little color was needed as the paper is also dark. The colors used for the halftone lights are yellow ochre and burnt sienna mixed, of course, with white, well diluted with plenty of water. A little purple, crimson, and green, are the other three colors that were found necessary to complete this plate.

Notice how the untouched gray paper assumes luminous qualities after the halftone lights and the purple-gray sky have been painted in, and also the very interesting tone created by yellow ochre and white when painted thinly on the gray paper. This effect is seen on the wall of the cottage towards the right, as well as in the light across the road in the foreground.

Plate XLV gives the final stage of the previous plate (*Cottages of Beure near Besançon, France*). The shadow colors consist of a little ivory black, burnt sienna, violet, and white. In finishing dark shadows, the very smallest particle of white should be used, as pure liquid color washes not only deepen the tone of the paper, but also help to retain the luminous atmosphere peculiar to shadows. The colors should be mixed as near as possible to the desired tints *before* painting, and, unless shadows of this type are painted in a direct manner, it is generally fatal to try to alter the result. The vertical supports, beams, windows, etc., were painted on top of the deep shadows while still damp. Yellow ochre—and in places burnt sienna—was mixed solidly with white for painting in the highlights. Touches of light gray were also introduced, otherwise a certain crudity would be noticeable in the lighter portions of the picture. All the highlights were painted in while the ground color was still wet.

Thick Opaque Watercolor

In the previous pages, thin and medium opaque watercolor was dealt with, and the addition of lots of water was necessary to get these results. Now, descriptions are given of the application of thick opaque watercolor for the final painting of a picture.

Plate XLVI shows the first stage of a painting in opaque watercolor entitled *A Pas-de-Calais Scene*. In this stage plenty of water was used so as to cover the ground quickly and more or less lay out the plan or composition of the subject. The color of the paper, which is a light, warm yellow, is noticeable in the cloudlet at the top of the picture. So much has already been mentioned of the possibilities relating to color washes that the student should be able to see how the warm color of the paper affects the thin color washes over it.

In the final painting of *A Pas-de-Calais Scene* (Plate XLVII), the sky was dealt with first, being painted with solid opaque watercolor. The farther distance (hills and trees) was painted over the lower part of the sky while still wet. Owing to the thickness of the pigment used, the contours of the hills and trees silhouetted against the sky were kept sharp and clearly defined. This result is not so easy to achieve when the painting is done on a thin, wet coat of opaque watercolor.

The various tones from the distant hills down to the nearer foreground were deepened, and detail was added to the trees, and other features.

It is merely a matter of additional time to suggest more detailed forms in a landscape of this type of scenery, but the artist preferred to insist more on the general decorative pattern of a decorative subject.

The first stage of the picture entitled *A Glimpse of Besançon Cathedral, France* (Plate XLVIII) requires as much thick color pigment in the preliminary painting as in the final stage. The paper on which this subject is painted is dark brown, but not cool in tint like the examples on Plate XLI, and therefore requires more drastic treatment from a color standpoint.

The preliminary outlines and shadow massing in the trees and foreground were done with indelible India ink mixed with Vandyke brown. The purple-gray sky was then painted behind the trees; also the various warm, light colors, as well as the deep blue and purple shadows spaced about the cathedral. It is very interesting to observe the growth formations of the tall trees caused by the contrast of light versus dark. The importance of correct color spacing cannot be over-estimated as it is the foundation on which the apparently accidental finishing touches are built.

Finishing Touches

To manipulate thick color pigment with any success on dark paper necessitates the use of a very large mixture of white in the highlights of the painting. This, however, will bring about disaster unless the painting is done with quick, decisive touches. The paintbrush must be fully charged, so that the paint (despite its thick consistency) is almost falling off the brush before being applied to the paper. Even then, as a rule, the color is considerably darker after drying than when freshly painted, more particularly if the paper is of an absorbent nature.

In the final stage of *A Glimpse of Besançon Cathedral, France* (Plate XLIX), it became a comparatively easy matter to suggest more detail in the contours of the trees and the painting of touches of lights on the trunks and branches, in addition to the lights flickering across the foreground at the foot of the picture. Clean water and a small sable brush were used occasionally to soften the edges of the highlights and other portions of the picture.

PARISIAN ROOFTOPS by Ogden M. Pleissner.

Here is a particularly meaningful example of the ability of watercolor to render a great variety of textures. The reader should study the extraordinary range of strokes, drybrush passages, and delicate washes which are used to render the walls here. The lighter walls are painted in constantly varying, broken washes and strokes of delicate tone, through which the tooth of paper constantly breaks. Over these tones come dabs of semi-dry color, strokes with an almost dry brush which leave mere touches of color on the high points of the paper, wandering lines which are broken by the texture of the paper, and dabs of relatively heavy color (which appears *to be the consistency of paint squeezed directly from the tube). Each architectural element has been rendered in the appropriate stroke: compare the strokes used to paint the rooftops with those used to interpret the wooden fence in the immediate foreground at the very bottom of the picture. The artist has also made subtle use of light to control the viewer's attention: almost the entire composition is in shadow except for the center of interest, where a flash of sunlight illuminates the curtains blowing from the window and picks up a few edges of the surrounding windows. (Photograph courtesy* American Artist.)

chapter
fifteen

VARIOUS
DEVICES

THERE ARE SEVERAL WAYS of using opaque watercolor. The most common method in use is to mix solid white paint with ordinary watercolor wash. To do this with a certain standard of correctness, it is as well to obtain the necessary strength or delicacy that may be required in color and tone by mixing the required tints before beginning the actual painting. A small palette knife is invaluable for this purpose. To mix colors and white with a brush not only takes up a good deal of time, but soon wears out the brush itself. Moreover, the grinding power of a palette knife reduces the various colors to an even consistency which can easily be applied with a brush on the tinted paper.

Water

It is an excellent exercise for the student to mix a tint of bright opaque color of light tone and, with very little added water, to paint solidly a small patch of this color on a fairly deep-colored paper (olive tint, for preference). Then use the same color again with more water, and paint another small patch near the first painting, and continue in the same way by adding more water at each attempt until at least six have been done, the last, of course, being generously diluted with water.

It soon becomes apparent that the greater the quantity of water used with the opaque color on tinted paper, the darker the color becomes when applied to the paper. By painting six or more washes of the same color in this manner, the student should have no difficulty in demonstrating the tints of the same color, varying in gradated stages from the lightest tint to the darkest.

If this practice were carried out for a few minutes every day for a month, the student should then be able to comprehend all that is necessary for the manipulation of different tones in opaque color on tinted papers.

Tempera White

Plate L illustrates several examples of interesting experiments, all painted on white drawing paper. Experiment A gives the brilliancy of color that results from using a flat wash of liquid transparent lemon yellow on the top of a flat coat of opaque white. The white paint was allowed to dry completely before the lemon yellow wash was laid on. A square sable brush, about ¾″ wide, was used for all these opaque watercolor experiments so as to allow the ordinary color washes to be quickly and lightly painted, and leave the color underneath undisturbed. Experiment C is just a pure wash of burnt sienna, and D illustrates the result of a thin coat of gouache painted rapidly over the burnt sienna tint. Notice how the warm tone of the burnt sienna changes under the influence of a little white, diluted with plenty of water.

Color Washes

At this stage, students are advised to try to work out, on similar lines to the examples shown on Plate L, as many schemes of washing, one color on another color, as may be possible, but always with a wide chisel-shaped brush, so that a large area can be covered with each stroke. A charming effect can be obtained by laying on a liquid wash of light violet tint, over a groundwork of lemon yellow opaque color, as demonstrated in the top right experiment (B); or a well-diluted wash of viridian over cadmium opaque color. There are, of course, hundreds of other color effects along these lines, beginning with the use of quiet, restrained colors, and leading up to brilliant color schemes.

Alternating Washes of Opaque and Transparent Watercolors

It must be quite obvious to the student of watercolor painting that the possible experiments on the use of alternate washes of opaque watercolor and transparent watercolor open up a big field for individual ideas and tastes. The bottom experiment (E) in Plate L represents a fascinating exercise in washing various pure colors on a prepared ground of white opaque watercolor. The groundwork is quite easily rendered by placing on the paper, at fairly regular intervals, large spots of white paint (well ground with a palette knife and mixed with water before painting). When the white paint is nearly dry, begin painting with pure wash colors, mixed with perfectly clean water. As soon as one color tint is finished, apply (with another brush) the next color, just touching the first color, but do not try to blend these two colors, as the white below will do this without any assistance from the painter. By preparing all the color washes before laying them on, and seeing that each color has its own particular brush ready for immediate action, the student should find no difficulty in bringing about an interesting result. If some of the spots appear to be too prominent during the wash painting, they can be toned down by working the wet brush over them several times until the circular edges become more or less dissolved in the surrounding colors. Some suggestions of white groundwork are here made for further developments apropos this exercise:

(1) Parallel lines or curves.

(2) Interlacing curves.

(3) Squares interspersed with small spots.

(4) Outlines of human figures showing folds of garments, such as the skirt, blouse, etc.

There are, naturally, many other ways of expressing form in white opaque watercolor. It is easier in this particular instance to work on white, or nearly white, drawing paper, as the color washed over the prepared groundwork is more able to retain its pure brilliancy.

In Plate XI, two vertical shapes on the top left and right, respectively (C and D), show as nearly as possible the same depth of color, D being an example of a pure watercolor wash, while C is of approximately the same color, painted in opaque watercolor. This illustrates clearly the important, although simple, fact that any tint of opaque color painted with solid consistency results in an opaque surface, whereas nearly every watercolor, if washed in with a generous amount of water, creates the illusion of transparency. White, mixed with a transparent watercolor, not only causes the transparent color to become thicker in its consistency, but also through its opaqueness tends to shut out the color of the tinted paper on which it is used.

Sponging Out Opaque Watercolor

In Plate LI also are two demonstration sketches (A and B). In A, a flat ground wash of opaque watercolor, which was carefully mixed and prepared before painting, was laid with a large brush on the white paper. While this color was quite wet, a good-sized, damp sponge was used rapidly for sponging out the lighter portions of the sketch. No time was lost between the flat painting and the sponging out. The sponge should be cleaned in clean water after each patch of opaque watercolor is wiped off the surface, unless there is any special reason for not doing so, such as an attempt to secure a halftone tint ranging between the highest light of the drawing paper and the depth of the opaque watercolor, but at first it is as well not to try this. If the color is allowed to dry before the sponge is used, it becomes exceedingly difficult to control the medium, and the contours of buildings, etc., assume a harder and sometimes a lacerated edging, instead of the softer artistic surface as appears in the illustration.

Sponging Out Opaque Watercolor

There are several subjects in landscape painting for which this method of sponging out opaque watercolor is peculiarly suitable. For example, the difficulty of rendering swift, moving clouds in watercolor has long been a great obstacle, even to advanced professional artists. With a little damp sponge, all manner of suave, light-tinted shapes can be made on the surface of wet opaque color, when painted over white or cream tinted drawing paper. The cloud illustration in sketch B (Plate LI), shows a dramatic rendering of

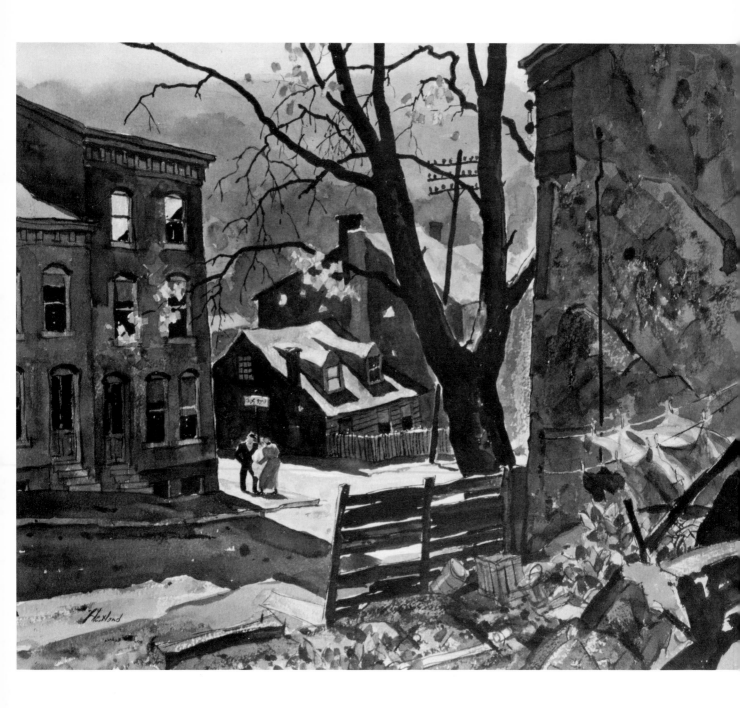

LEVERING STREET CORNER by W. Emerton
Heitland.

*The artist has used a carefully designed lighting
effect to simplify and focus what might be a
cluttered composition. Nearly everything in this
townscape is in shadow: the wall and debris in the
foreground; the sides of the buildings which face
us; the fence; and the central tree. But a flash of
light breaks across the street in the center of the
picture, framing the figures at the bus stop and
illuminating the rooftops nearby. The lighted street*
*is completely surrounded by dark shapes, including
not only the walls, but the foreground shadow
across the street. And the big shape of the tree
leans over the focal point of the picture and sur-
rounds it. It is interesting to observe that the geo-
metric forms of the buildings are consciously
redesigned to be jagged and irregular, rather than
cool and precise like an architectural rendering.
(Photograph courtesy* American Artist.)

heavy rainclouds. All the sky and landscape were painted with one coat of opaque watercolor, as demonstrated in sketch A, and the same method was used for sponging out so as to obtain the various shapes of clouds. The landscape below was painted over the first coat of color, and the sponge was used sparingly over this portion of the picture.

There is no reason why more than one color in the same opaque watercolor cloud sketch should not be used, but it is advisable to practise continually with one color only so as to obtain a complete mastery over the intricacies of a simple sponge. (See Chapter Fourteen for further remarks on opaque watercolor.)

Thin Washes over Pencil Drawing

In Plate LII (the picture entitled *The River*) the subject, in its initial state, was drawn carefully in lead pencil, with a fairly black line. Then a warm gray was mixed, to which was added a large quantity of water. The drawing paper having been placed in an upright position on an easel, a large brush was dipped into clean water and then applied to the thinly-mixed opaque color. The opaque color was painted horizontally across the paper rather rapidly, until the whole picture ground was covered, including, of course, the pencil drawing. The semi-thickness of the tint used made a vertically-inclined streak appear in the painting (caused by the upright position of the paper), which has a certain agreeable quality of textural value. The paint was not thick enough to disguise the drawing beneath. A certain mannerism was adopted in suggesting the general shapes of trees, figures, and boat, etc., before the solid color masses were painted in, by strengthening their outlines, or contours, with a small sable paintbrush. In the contours of the tree foliage, a lesser and more open touch was found desirable, so as to obtain a feeling of flexibility as well as of movement. Care was taken to paint the large color washes (which were done in liquid wash without any admixture of white) before the painted outlines had the opportunity of drying, and so hardness of outline was avoided.

The light on the water was obtained by sponging out before the opaque watercolor surface was dry. Notice how the paint representing the general masses of the trees has almost entirely lost the vertical streaks seen in the sky. This was the result of using transparent wash over the opaque watercolor. It is important for the student to note that in attempting an exercise of this sort he must work the brushes rapidly and with decision. For lightly-suggested subjects, such as might be used for landscape effects of a misty day, this style of painting can be strongly recommended.

It must be obvious by now to students of watercolor painting that there are many ways of approaching different subjects in this interesting art. The subject should create its own style of technique. Lucky is the artist who has more than one string to his bow. Intelligence in the matter of different techniques in watercolor painting is no drawback to the artistic mind. Turner showed considerable resource in this respect. To paint in one method only is apt to breed dullness after several years of watercolor painting.

BIG CITY by Herb Olsen.

This is a powerful example of a watercolor done on wet paper. The series of background buildings, occupying the right hand half of the composition, were painted on wet paper, which blurs the outlines of the buildings and makes them recede into deep space. The nearer buildings are rendered in heavier paint, which does not blur quite so much as the distant buildings, which are painted more thinly; this gives an effect of atmospheric perspective because the darker buildings seem closer. The *effect of atmospheric perspective is even stronger in the foreground, where the subway station and tracks are rendered in really dark paint, which contrasts strongly with the distant buildings. Thus, the picture actually divides into three planes: the dark, relatively sharp-edged foreground; the lighter, soft-edged middle distance; and the very pale, very soft-edged extreme distance, in which the buildings literally melt into the sky. (Photograph courtesy American Artist.)*

chapter
sixteen

OPAQUE WATERCOLOR AND SOAKED PAPER

TAKE SMALL SHEETS of various papers, immerse them in a bath of water and leave them overnight. Next morning, they will be in relative conditions of absorption, according to the amount of size in their composition—the less size the more sponginess.

Paper Moisture

Apply the same tests to each paper. Take it out of the bath and lay it on a piece of glass so that it will retain its moisture. Place it in a horizontal position and drop colors on to it, controlling their movements as far as possible with a brush. Note that the color spreads violently, but can be wiped off far more easily than from the same kind of paper when dry or merely damped. Take another piece of the paper, remove the surface moisture with blotting paper, and repeat the experiment. This time the color is more easily controlled, but can still be wiped off without difficulty. As the paper dries, the possibilities of control increase, except that of wiping out, which decreases.

Imagine, then, what could be done if the picture were started when it was taken out of the bath and finished when the surface had become dry. Any variety of gradation, and variety of edge, from the softest to the sharpest, could be painted when the paper was in just the right state of moisture.

Obviously, such a method would test the skill of a highly-experienced craftsman, but it would give unusual scope to the imaginative artist.

Painting over Chinese White Ground

A peculiarly attractive and somewhat easier variation of the method described is illustrated in Plate LIII. In this case, the paper chosen was of highly absorbent quality, which became sufficiently saturated in an hour.

A QUIET MORNING AT SAKONNET
by Harry Anderson.

This is a particularly bold use of opaque water-color to render an effect of broken light. The strokes follow the forms in a free, spontaneous, but carefully calculated way. Thus, the curving sides of the hull of the boat at the center of the picture are rendered in strokes that move around from the sides to the prow. In the same way, the erratic, wriggling reflections of the boats and the posts in the water are handled in strokes that swirl like the water itself. The current of the water is indicated *by long, lazy strokes that actually seem to move along with the current. The opacity of the paint is particularly valuable in the light passages, where heavy strokes of light paint are piled up over the darks to indicate the flicker of light on the water; it is much easier to paint this kind of effect in opaque watercolor than in transparent watercolor, since the opaque medium allows you to paint light over dark and the transparent medium doesn't. (Photograph courtesy* American Artist.*)*

After placing the paper on a sheet of glass, cover the whole surface with a coat of Chinese white. Into this wet ground, paint very lightly. Aim first at an undertone for each part of the picture, disregarding all details (including the figures)—both light and dark—blue and gray for the sea, and varied grays for the rocks. Paint with transparent colors, brighter and darker than required, to allow for modification by the ground of white. As the picture dries, wipe the color from the foam and the figures, and define the shapes. If the paper does not dry quickly enough, take it up and lay it on a piece of dry blotting paper; if it dries too quickly lay it on a few sheets of soaked blotting paper. When the paper is in the right state deal with the details, add white for the lighter parts. The sharp edges should be rendered last of all when the paper is almost, but not quite, dry. Given a highly absorbent paper, the picture need not be finished at a sitting; for if laid on soaked blotting paper, all the color will become moist again, and can be manipulated without difficulty.

When to Use Soaked Paper

Although this is not a method for a beginner, nor for anyone who has to rely on a preliminary outline, it is not quite so difficult as may first appear (if the picture is rather small and the subject chosen is a simple one), because, in the early stages the shape can be altered quite easily by taking off any part of the color with a clean brush. But as it is hardly possible to tell, without a good deal of experience, exactly how much lighter each part will dry, the method is best suited to subjects characterized by brilliant color and powerful contrasts rather than by subtle tone relations. Windy subjects, dashing water, fluttering trees, flickering lights, moving clouds, and shadows, can be rendered with comparative ease. Flat tones, even gradations, exact form, and delicate distinctions had better be attempted in more suitable methods.

Here, as in the case of granulation, is an ideal method for the promotion of accidental discovery. Drop masses of color into a base of Chinese white in the most irresponsible way, and, more likely than not, an idea will emerge. If it does not, wipe the color off and try again. When stimulating impressions do happen, which can be carried no further for lack of the necessary facts, preserve the experiments and collect details for future pictures based upon these impressions.

Interesting variations might be made by mixing some color with the preliminary coat of Chinese white, and so securing a prevailing tint or tone from the beginning.

An adaptation to portraiture and decorative figure subjects can be made extraordinarily striking in the hands of a brilliant technician. Use a thick, handmade paper and draw the figure with a firm line. Paint the background first, and when the paint covers parts of the figure, as it is bound to do, wipe it off. In the later stages, when the paint is more easily controlled, it will be possible to remove all the color from the figure, which can be painted later on when the background is dry.

BLUE-PURPLE by Joseph L. C. Santoro.

The dark masses of the distant mountains and the dark and light masses of the foreground are painted broadly, with a minimum of detail. The bare trunks and branches of the trees are indicated with crisp, decisive strokes of dark against the snow. Where the shapes of the trees appear against a dark background, they are scratched out with a sharp tool. The sky is painted wet-in-wet. Throughout, the landscape is animated by drybrush textures. (Photograph courtesy of the artist.)

chapter

seventeen

PAINTING WITH DRY PIGMENT

WATERCOLORS ARE, of course, dry pigment mixed with a little adhesive to make them stick more firmly to the paper. If pigment alone is mixed with water, and spread over the surface in the form of a wash, it will come off just as if it were pastel gently rubbed in; that is to say, it will stick slightly. If the wash is very thick, that is, if a small proportion of water is used, the color will come away in flakes. In any case, however thinly applied, it is fragile; and if applied too thickly it is a failure. But with careful treatment (and preservation) it has distinct possibilities, as it possesses much of the charming texture of a pastel, combined with qualities of watercolor.

Why Work with Dry Pigment?

Dry pigment granulates more freely than watercolors, and experiments will prove that they can be made to run and dry in unique ways. But the main attraction of the method is the fact that the color can be taken out, quite easily, with an eraser. Strong pressure will remove the whole of the pigment; softer pressure will leave a little behind. Consequently, the lights thus obtained may be exactly the colors of the paper or various paler tones of the color applied. Also (and this is an important point) a clean, damp brush will take out clear patches with the greatest ease.

Applied directly to white paper, the method is limited, because the strong lights are bound to be white; but by using undertints of indelible inks, in the manner described in Chapter Thirteen, this limitation could be overcome. Notwithstanding the limitations of the method, however, delightful effects are obtainable in appropriate subjects.

Suitable Subjects for Dry Pigment

Plates LIV and LV illustrate simple experiments with two of the most suitable types of subject: white clouds on a clear sky, and passages of light on shaded white walls. These subjects were selected as suggestions for preliminary experiments, to be extended when the possibilities of the method have been discovered by further investigations.

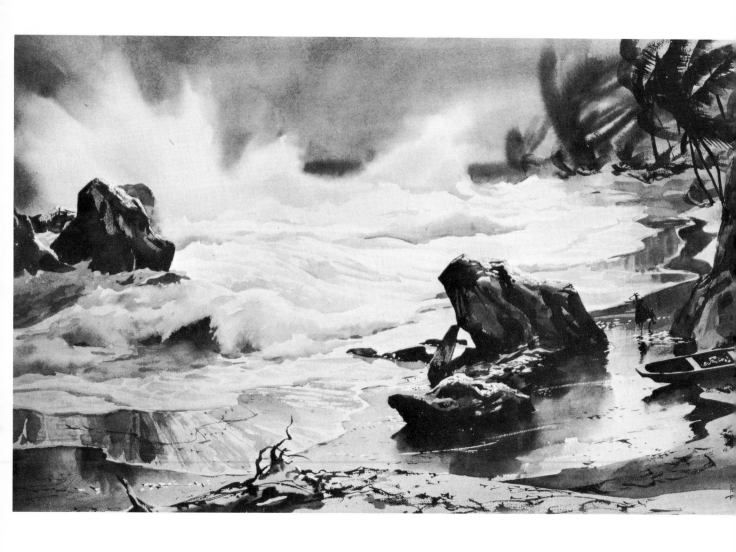

BREWING STORM, JAMAICA by John Pike.

The power of this explosive watercolor is actually the result of very careful study of values and a very knowing placement of lights and darks. The explosion of white foam is framed between the two darkest notes in the picture—the rocks—and is encircled by a variety of subtle middle tones. The various delicate grays in the foreground are all based on careful observation of reflections in the wet sand and the pools of receding water. Although the sea appears to be flooded with light, much of it is actually in soft shadow, and the bright lights *are reserved only for the high points of the surging waves. Like the dark rocks—which are silhouetted against the lighted water—the water is actually painted as a series of solid forms with light and shadow sides, so that the waves are distinctly three dimensional. The painting of the foreground rock formation is particularly instructive: notice how the light, halftone, and dark areas are picked up in the reflection of the rocks in the tidal pool—the reflection is designed as carefully as the rocks are.* (Photograph courtesy American Artist.)

chapter
eighteen

LUCKY
ACCIDENTS

WHEN THE INEVITABLE FAILURE OCCURS, with attendant disgust and weariness, it is a common practice to destroy it at once, as an expression of feeling and an aid to forgetfulness. An absurd proceeding, for in this way a potential success may be lost. Far wiser to put it away, swallow disappointment, and determine to try experiments when in a suitable state of mind. Should a picture fail to emerge, valuable lessons may be learned and employed later upon more tractable material.

Use your Failures for Experimentation

In this connection, Plate LVII is included in this book, solely on account of its history. The original intention was to paint a striking picture by means of powerful contrasts—dark sky; emphatic clouds; dense, cold hills; and warm, bright foreground.

The result was all too literally striking—enough to knock one down! And to add to the misfortune, most of the color resisted all attempts of sponge and energy to dislodge it. Only the black hills could be induced to fade. As a last, and by no means hopeful, resort a wash of thin Chinese white was laid over the whole surface with no perceptible improvement, except that the picture became too cold. Then a little varied warm color was added to the white, and after six successive washes, the picture arrived at its present state, except for the sheep and a few touches on the foreground.

Accidents can be Lucky

Lucky accidents do sometimes occur to the most unfortunate. A sponge or a jet of running water has been known to work wonders. Recently, one of the writers had made an undeniable mess of a subject composed of downland with prominent groups of trees in the middle distance. A few passes of the sponge heightened the general tone and took away the whole of the trees, leaving patches of pearly light in place of the dark masses. There were two pleasant consequences—an unexpected picture and an immediate sale!

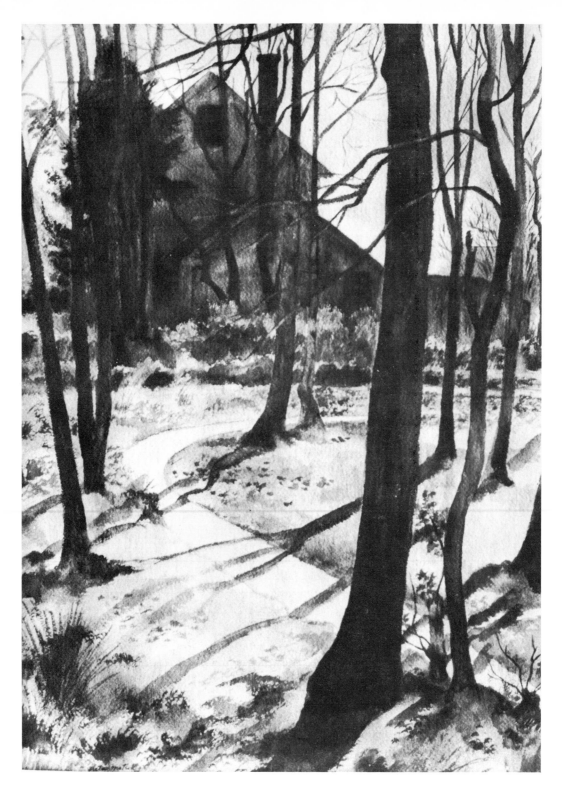

WINTER TREES by Greta Matson.

This is an unorthodox composition, but an effective one. The center of interest is the dark building which is half hidden beyond the trees. The viewer's attention is directed through the foreground along a path of light which leads to the background—an unusual, but effective place for the focal point of a painting. The lighted foreground might actually detract from the darkened building, but the artist has repeatedly interrupted the foreground with splashes of tone, and with tree shadows that cut across the viewer's path. The tree shadows indicate that the light enters the picture diagonally from the right and from behind the subject, which accounts for the fact that the shadows actually come toward us. (Photograph courtesy American Artist.)

chapter
nineteen

ACCESSORIES

No PAINTER OF WATERCOLORS, however clever and resourceful, can afford to neglect the problems relating to impedimenta and accessories. What is the most suitable easel, paintbox, stretching apparatus? These and several other questions call for settlement.

Easel

In some cases the answer depends upon special individual requirements. For example, the best kind of easel, if any, may depend upon the method of painting adopted. One of the present writers regards any sort of easel as an intolerable nuisance, and has not discovered anything better than a table because he generally paints in a very wet method which necessitates the keeping of the picture in a horizontal, or nearly horizontal, position.

The method of painting ought to determine the choice of any easel. For the drier methods, the ordinary kinds (which hold the picture almost upright) will do. For the wetter methods, an arrangement by which the picture can be held in a nearly horizontal position is essential. The drawing table, used by most artists who work in black-and-white, or perhaps better, an architect's drawing table, is eminently practical. For comparatively small work, and for sketching, there is an easel composed of a tripod surmounted by a movable holder, enabling the angle of the picture to be changed at any moment. A visit to a few art supply shops and architects' supply shops (or, if that is impossible, the perusal of their illustrated catalogues) should settle the question.

Storage Space and Equipment

In other cases, unfortunately, the choice depends upon financial circumstances. Those who have no need to spare a little expense would do well to

secure certain conveniences and appliances which always make for efficiency. Perhaps the most important is a really satisfactory place for storing paper. The best arangement we know is a chest of shallow drawers with hinged fronts, used by architects, and called a blueprint file. It should be large and with sufficient drawers to take everything of the kind required, and to allow for division into drawing, tinted, hot pressed, cold pressed, and mounted paper, sketches, finished pictures, and what-not.

Matboard of various shapes, sizes, and patterns, with frames to match, should be regarded as necessities, because it often happens that a picture which turns out to be unsatisfactory on the scale originally intended, is transformed when cut down to another size and shape. And it is very helpful to look at the picture behind the mat at various stages of the work. Many a picture has been ruined by over-elaboration in consequence of the neglect of this obviously reasonable precaution.

There is no excuse for the absence of a large T-square and triangle. Pictures in which houses, towers, and walls threaten to topple, and reflections take impossible directions are true signs of the amateur (in the uncomplimentary sense of the word).

Paintbox

The best kind of paintbox is a never ending topic for discussion. Here again the method of painting is bound to influence the choice. If one paints in large washes at a table, there is little need for a box of any kind. A nest of white saucers and tubes of color are more useful for all but the final touches. If, however, a box is in constant use, the question of tubes versus pans of color becomes important. To buy filled pans is open to one grave objection—the color is almost certain to get dirty and mixed with some of the others. A large brush charged with a dark color accidentally thrust into a full pan of very moist pale color may destroy the purity of the whole. One satisfactory plan is to buy empty pans, squeeze in a little color at a time, and clean them frequently.

There is much to be said for large tubes containing certainly at least four times as much as the ordinary "whole tubes." They are considerably cheaper, and small tubes encourage the suicidal tendency to be stingy instead of lavish.

Water

A large supply of clean water (there is no more convenient receptacle than a huge glass jar) is essential. It is sheer childishness to try to paint a clean picture with dirty water.

Paper-stretching Apparatus

The havoc wrought by uneven paper justifies the possession of the best obtainable stretching apparatus. The usual method—that of damping the paper, laying it on a drawing board and pasting the edges is rarely satisfactory except for moderately thin paper and on a small scale. Often it peels off,

stretches insufficiently, and buckles when painted on, or splits because it is etched. There are several kinds of stretching appliances, more often used by architects than by artists, which can be manipulated in a few minutes with invariable success. All things considered, nothing can equal a prepared board, i.e. paper pasted on thick cardboard, but it must be pasted by hand, as the pressure of machine rollers takes all the character out of the surface of any good paper.

As with methods so with materials: personal investigation, if pursued with thoroughness and intelligence, is always more fruitful than the blind acceptance of the best advice.

SUGGESTED READING

Acrylic Landscape Painting, by John Pellew, Watson-Guptill, New York

Complete Guide to Watercolor Painting, by Edgar A. Whitney, Watson-Guptill, New York

Herb Olsen's Guide to Watercolor Landscape, by Herb Olsen, Reinhold, New York

Landscape Painting Step-by-Step, by Leonard Richmond, Watson-Guptill, New York

Painting in Watercolor, by John Pellew, Watson-Guptill, New York

Painting Trees and Landscapes in Watercolor, by Ted Kautzky, Reinhold, New York

Starting with Watercolour, by Rowland Hilder, Watson-Guptill, New York

Watercolor, by John Pike, Watson-Guptill, New York

Watercolor Landscapes, by Rex Brandt, Reinhold, New York

Watercolor Made Easy, by Herb Olsen, Reinhold, New York

Watercolor Painting Step-by-Step, by Arthur L. Guptill, Watson-Guptill, New York

Watercolor with O'Hara, by Eliot O'Hara, Putnam, New York

Ways with Watercolor, by Ted Kautzky, Reinhold, New York

Whitaker on Watercolor, by Frederic Whitaker, Reinhold, New York

INDEX

Edited by Margit Malmstrom
Designed by James Craig and Robert Fillie
Composed in nine point Aster